TREASURES OF IMPERIAL JAPAN

Ceramics from the Khalili Collection

OLIVER IMPEY

MALCOLM FAIRLEY

AMGUEDDFA GENEDLAETHOL CYMRU
NATIONAL MUSEUM OF WALES

The Kibo Foundation gratefully acknowledges the
support of the President and Council of the National
Museum of Wales

Published in the United Kingdom by the Kibo Foundation
The Kibo Foundation is part of the Khalili Family Trust

The Kibo Foundation
Nour House, 6 Hill Street,
Mayfair, London, W1X 7FU

A catalogue record for this book is available from the
British Library

ISBN 1–874780–06–4

Co-ordinated by Andrew Keelan
Design and art direction by Martin Bragg
Photography by Alfie Barnes
Typeset by Martin Bragg Associates
Reproduced by Regency Scanning
Printed and bound in the United Kingdom
 by Bath Midway Press

CONTENTS

TREASURES OF
IMPERIAL JAPAN

Ceramics from the Khalili Collection

OPENED BY

HIS ROYAL HIGHNESS THE PRINCE OF WALES

AT THE

NATIONAL MUSEUM OF WALES

Monday, 24 October 1994

THE National Museum of Wales has large holdings of European ceramics, in particular the de Winton gift of eighteenth-century porcelain and the national collection of Welsh ceramics, but the ceramic art of the Far East is represented in Cardiff only by a small number of comparative pieces, most of them Chinese.

We are therefore deeply grateful to Dr Nasser D. Khalili for offering to us this exhibition of Japanese pottery and porcelain of the Meiji period, which coincides with the showing of lacquer, cloisonné enamel, and metalwork from the Khalili Collection in the Japanese galleries of the British Museum. Dr Khalili's collection is unrivalled in scale and scope, and the exhibition is a unique opportunity to see and appreciate the virtuosity of two of the greatest ceramic artists of this period, Makuzu Kozan and Yabu Meizan.

Nineteenth-century Japanese art is relatively little known in the West today, but it had a profound effect on Victorian design from the 1860s. Its asymmetry, colour, and exuberance delighted William Burges, the architect of Cardiff Castle. A pupil of Burges, Josiah Conder, became the father of Western architecture in Japan, and it is the cross-fertilization of Japanese and British art and culture during the Meiji period which gives this exhibition an especial appeal.

On behalf of the President and Council of the National Museum of Wales, I want to thank Dr Khalili and the Kibo Foundation for their generous and enthusiastic support of this exhibition. It is a measure of the importance of the occasion, and of the growing Japanese community in Wales, that His Royal Highness The Prince of Wales has graciously consented to open *Treasures of Imperial Japan*. Wales has seen considerable inward investment from Japan in the last decade. This exhibition provides an opportunity for the very welcome newcomers—and all our visitors—to enjoy the superlative quality of the finest art and craftsmanship of the Meiji era.

COLIN FORD
Director
National Museum of Wales

IN the 1850s and 1860s Japan emerged, with a degree of reluctance, from the isolation of the Edo period, which had lasted for two and a half centuries. There being no infrastructure available for overseas trading, one of the first things that could be exported was the unparalleled skill and ingenuity of the Japanese artists and craftsmen. Immediately the almost unknown works of art of this era began to attract the attention of artists, scholars, and collectors around the world. Hitherto, the only art forms to emerge had been export works of decorative art which bore little relation to those favoured in Japan itself. This new internationalism, however, heralded by the advent of the Meiji dynasty, caused a new art form to evolve which was also of great interest. Highly desirable and of the finest quality when they were made, such works of decorative art lost favour in the West after the turn of the century. This was due to a general decline in the appreciation of Victorian styles and to the rise of modern tastes. But it was the sheer quality and beauty of Meiji art that caught my imagination.

Over the last twenty years I have been assembling collections in a number of different fields, ranging from Spanish metalwork and the arts of the Islamic world to Indian and Swedish textiles. In the course of my collecting activities I came across several examples of Japanese decorative arts of the Meiji period, and I was surprised by their technical excellence and striking designs. My surprise arose from the general lack of information on the arts of this period, but, rather than putting me off the trail of these impressive art forms, this dearth of easily accessible information actually whetted my appetite for the subject. I therefore began to follow up my interest by acquiring any background knowledge that I could.

The forty-four years of the Meiji period, from 1868 to 1912, proved to have been strikingly productive, in terms both of design and of technical development, but the tradition of decorative arts established during that time did not survive for long. For this reason it seemed a real possibility that I would be able to build up a representative collection that covered the whole period. At first I pursued the task on my own account, acquiring objects slowly over a number of years, but eventually it became clear that my other commitments were not leaving me enough time to complete the project to my own satisfaction. I was therefore very fortunate in securing reliable and knowledgeable assistance in assembling the Collection.

In the course of these collecting activities my aim has been to select only items of the first quality, whether they be lacquer-wares, metalwork, enamels, or ceramics. These artefacts were made mainly for the Imperial Household, both for personal use and for presentation as gifts; for domestic consumption and exhibition at the various National Industrial Expositions; and for international exhibitions and trade fairs, where the craftsmen who had perfected their techniques could publicize their creations to the world.

The Collection consists of nearly 800 items, of which some 100 earthenware and porcelain pieces are exhibited here. All the major artists are represented, including Yabu Meizan, Kinkozan, Hankinzan, Makuzu Kozan, and Seifu Yohei.

Yabu Meizan and Makuzu Kozan are the artists whose works make up the majority of the ceramic collection. The former, working in earthenware, produced a style and fineness of detail that set him apart from his contemporaries. His work

resembles that of the enameller Namikawa Yasuyuki, both men being interested in the development of traditional forms and designs. I have assembled over a hundred pieces by this artist, which I hope will provide a useful basis for future scholarly work in the field.

High among my affections in the Collection are the exquisite works of Makuzu Kozan, renowned as one of the greatest ceramic artists of his day. Formerly working in the Satsuma style, this master, after moving his operation to Ota at the onset of the Meiji period, evolved into the field of porcelain. Although he concentrated on showing his creations at the international trade fairs, his designs and subtle use of colour were also well known in Japan.

I have derived a great deal of pleasure in bringing the Collection together. Some of this enjoyment was purely aesthetic, and some has its source in the technical mastery displayed by the artists. The process of collecting has itself allowed me to gain a deeper understanding of the qualities of Meiji decorative art, for the objects gain much by being studied as a group.

The loss of some of the traditional practices that gave rise to such exquisite work means that these objects can never be reproduced. This has added to my pleasure in acquiring them, and it has also excited my wonder at their intrinsic qualities. I hope that others will now come to share my view. It is therefore my hope that the publication and exhibition of the Khalili Collection of Japanese Art will establish these artefacts as worthy objects of study and bring them to the attention of a wider public, especially the Japanese, who have largely been deprived of seeing and appreciating these forms of Meiji art.

Some years ago, while formulating my ideas on exhibiting the Collection, I had identified South Wales as an area which had attracted much Japanese business interest and investment, and which seemed to be an eminently suitable venue for the first public showing of the ceramics in my collection. It was with this in mind that I approached the National Museum of Wales with a proposal that they should host such an exhibition. I would like to express my thanks to the director, Mr Colin Ford, for allowing the event to take place in this magnificent museum. My gratitude goes to Timothy Stevens, who has since moved on to the Victoria and Albert Museum, for help and advice during the initial negotiations. In particular, I would like to thank Oliver Fairclough, who has been directly responsible for the realization of the project.

Oliver Impey and Malcolm Fairley have provided the academic support that is vital in an endeavour of this kind, and to them I am most grateful. To my own team I extend my thanks, especially to Andrew Keelan, who has co-ordinated the project on my behalf from its outset. To Martin Lewis-Bragg for the design and production of this catalogue, and to Wendy Keelan for her assistance and support, I am most grateful. But I cannot conclude without acknowledging the understanding and affection shown to me by my wife, Marion, and the rest of my family while I was engrossed in another of my many enthusiasms.

NASSER D. KHALILI
October 1994

Japanese Ceramics of the Meiji Period

Oliver Impey and Malcolm Fairley

JAPANESE export porcelain, the Arita, Imari, and Kakiemon wares, has been familiar in Europe since the time of its importation between the years 1660 and c.1740. This has somewhat eclipsed the other ceramics of Japan, which are, perhaps, less well known in the West. The exception to this may be the so-called Satsuma earthenwares of the nineteenth and twentieth centuries, which will be discussed below.

In fact, Japan is really a country of stoneware, in that most of its kilns specialized in that medium. Earthenware has, of course, the oldest history, but in the fifth century AD kiln technology from Korea enabled high-fired wares to be made for the first time. These have the advantage over earthenware in that they are stronger and less easy to damage, and are impermeable to water; there was no need to glaze them, whereas earthenware had to have a lead glaze similar to that employed in Tang China. Some of the stonewares did have an ash glaze; at first this was accidental, caused by fly-ash in the wood-fired kiln, but later it was learnt how to apply a glaze that was a mixture of clay and wood-ash.

With stoneware technology came the wheel, enabling a finer product to be made faster than before. The kilns could now be fired in a partially oxidizing atmosphere, giving a pale- or red-bodied ware, whereas the Sue ware had been fired in a reduction atmosphere, where oxygen was as far as possible excluded from the kiln during firing and particularly during the critical, long cooling period, giving a dark-bodied ware. In the fourteenth century Chinese importations stimulated the production of imitations, mainly of celadon. The Chinese pieces were of porcelain, for China had been making porcelain since the eighth century; the Japanese copies, made in Seto, were of stoneware. The ash glaze mixed with a small quantity of iron could produce either the celadon green or the iron brown of the Chinese originals, albeit on a stoneware body. What is curious is that the wheel was (temporarily) abandoned and these Kamakura-period Seto pieces were coil-built. At this time these were the only glazed and decorated ceramics being produced in Japan, other kilns making utilitarian stonewares, jars, mortars, pouring-bowls, or food-bowls.

In the sixteenth century the centre of ceramic production shifted from Seto to nearby Mino, where decorated ceramics were made, many of them in 'tea taste', that is, useable either in the tea ceremony (it was only recently that Japanese ceramics had been thought fit for this purpose) or else in the *kaiseki* meal that would accompany a full tea ceremony. This meant that there was a large production of small bowls, dishes, and cup-shaped dishes (*mukozuke*) in the so-called black Seto, yellow Seto, Shino, and, later, Oribe styles. These too were mostly hand-built rather than thrown. The green-glazed Ofuke wares were for more ordinary use.

New kiln technology had been introduced from Karatsu, in Kyushu, the south island; it had come thither from Korea at the turn of the sixteenth century. This new

kiln, the stepped-chamber type, which made possible a much better control of the circulation of heat within the kiln than had previously been possible, rapidly spread throughout Japan, and was still in use until the introduction from the West of the coal-fired kiln in the late nineteenth century. In fact, it is still used today by many artist potters.

It was in the south-eastern part of the Karatsu area that porcelain was first made in Japan in the early seventeenth century. The early porcelains were made in the same kilns as the stoneware, for the technology and firing temperature (about 1,280 ℃) are more or less the same. The decoration was also similar; much Karatsu stoneware is decorated in iron-oxide (brown) painting under a transparent glaze; early Arita porcelain (*shoki*-Imari)—for south-east Karatsu is the same as north-west Arita—is usually decorated in cobalt-oxide painting under a transparent glaze (underglaze blue, blue-and-white).

In the 1640s overglaze enamel was first used in Arita for pieces of porcelain competing with the imported *kosometsuke* (Tianqi) porcelain from China, itself stimulated by *shoki*-Imari. It used to be thought that much of the early enamelled porcelain, in a particular dark-hued palette of enamels, was made in the Kutani kilns on Honshu, hence their name *ko*-Kutani (old Kutani). It is now recognized that all or nearly all of these wares were in fact made in Arita. It seems likely that these pieces were made for export to south-east Asia. By the time the Dutch East India Company started buying Japanese porcelains for export to Europe, these enamel wares were clearer and of brighter colours. We call the enamelled wares Imari, after the port through which they were shipped, and the porcelains without overglaze enamel, the underglaze blue pieces, Arita, after the town in which the kilns were situated; one special group, with finer colours and frequently with a finer porcelain body, is called Kakiemon.

Other porcelains were made in Kyushu in kilns near to Arita in the seventeenth century; no kilns elsewhere in Japan made porcelain except for a small production of a simple ware in Kutani (on Honshu). Of the kilns near to Arita, by far the best known is the Nabeshima kiln at Okawachi, which made presentation wares for the use of the Nabeshima lords of the area. By the seventeenth century many of the rough-stoneware kilns were making a finer product, often related to 'tea taste'; such were Tamba, Shigaraki, Iga, Bizen, Zeze, and Tokoname, to name but a few. Ceramic historians used to talk of the 'Six Old Kilns'; today more than thirty kiln areas are recognized.

In Kyoto, the cultural centre of Japan and the city of the Imperial Court, two new types of earthenware were made in the early seventeenth century. The Raku wares are very low-fired and hence soft; this was an advantage in their use in the tea ceremony (in which the Raku potters specialized) as the soft glazes acquired a patina of use, much favoured by connoisseurs. The overglaze enamelled earthen-

wares are called, generically, *Kyo-yaki* (Kyoto ware); the best-known of the wares are Awata and Kiyomizu: these had been much stimulated by the Rimpa-style wares of Nomomura Ninsei (*c.*1574–1660/6). They can clearly be seen to be ancestral to the so-called Satsuma wares of the nineteenth and twentieth centuries.

The early Kyoto wares were not made for export; nevertheless, a few pieces reached Europe in the eighteenth century, for some are recorded in the Dresden collection in 1719, and others are known mounted in French eighteenth-century ormolu.

The late eighteenth century was a time of prosperity for the ceramic industry of Japan. Although Arita had suffered from the loss of the Chinese market at the end of the seventeenth century, and of the Dutch market in the middle of the eighteenth, other kiln areas, many of them new, prospered. Of these, the most important in terms of quantity was Seto, and in terms of quality, probably Hirado; porcelain became increasingly popular.

In the early nineteenth century, with the Chinese revival marked by the Nanga school of painting, Kyoto potters (many of them Nanga-school painters) began to make porcelain imitations or pastiches of Chinese porcelain. This was the beginning of the porcelain industry in Kyoto (as opposed to earthenware) that was to become important in the Meiji period, after 1868.

The opening up of Japan to the West in the mid-nineteenth century, compelled by the West, after its three hundred-odd years of self-imposed semi-isolation, caused endless repercussions in all walks of Japanese life. To some extent the weakness of the shogunate and its inability to withstand the forces working for the 'restoration' of the Emperor were caused by factionalism over the question of how far Japan should tolerate Western intrusion. In fact, under *force majeure*, Japan was obliged to accept unequal treaties with the West. In 1868 the shogunate fell, and with its fall came the end of the quasi-feudal state under which Japan had lived in the Edo period. The removal of power from the lords in 1871 meant that craftsmen lost a major source of patronage; a new money-based market economy began which changed the face of Japanese crafts, as craftsmen began to respond to the Western market. The government was determined to industrialize fast, as it well saw that only industrialization would bring the possibility of military parity with the West, necessary in order to be able to renegotiate the unequal treaties. One part of the government's endeavour to industrialize was to encourage craftsmen to learn from and seek to sell to the West. Japan began to exhibit in the great world exhibitions that followed every few years in various countries after 1851. The first in which the Japanese participated had actually been before the Restoration, when the shogunate and two separate domains exhibited in Paris in 1867. The new Meiji government followed this example, sending a large exhibit to Vienna in 1873.

Japan's first adaptations to supposed Western styles, to sell in the Western

market, were not always happy; the products tended to be confused and over-embellished versions of traditional shapes. In spite of this, success at Vienna in 1873 was followed by success at Philadelphia in 1876, and possibly at Paris in 1889. Japanese crafts were less well received in Chicago in 1893, though they had greatly improved in overall design, and they were severely criticized in Paris in 1900. Meanwhile, Japan had set up its own National Industrial Expositions, to be held in years in which there was no international exhibition. These were based on Western models, subdivided into many sections, and were competitive; the best exhibitors were awarded prizes. Awards were made to the artist, but even more prestigious prizes would be given to the exhibitor, who had usually commissioned the object from the artist. Thus, the commissioners whose choice it was exactly which type of object should be exhibited were as highly regarded by the authorities as were the artists who actually made the pieces. The commissioners therefore exerted a very great influence upon Japanese decorative artists in the Meiji period. In fact, however, ceramic artists were more usually independent of commissioners than were, in particular, the metal-workers and lacquerers.

Much of this catalogue is concerned with the fine earthenware decorated in overglaze enamel colours and gilding generically called 'Satsuma'. This is a misnomer, for most of the wares thus classified were made (or at least decorated) in

Figure 1.
The studio of Yabu Meizan, from H. Shugio, 'Japanese Art and Artists of Today, II. Ceramic Artists', *The Studio*, vol. 50 (June 1910), p. 286

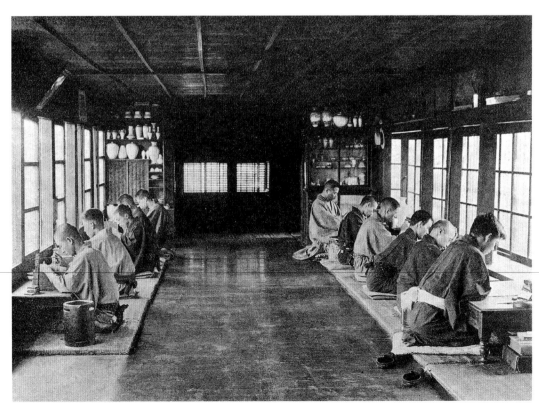

Kyoto, Osaka, Yokohama, or Tokyo. There had in fact been a small production of wares ancestral to these in the Satsuma domain on Kyushu island, but these were always small and delicately painted.[1] With the arrival of foreigners in Japan, numerous potters took to making copies or pastiches of these wares, and the style, if one can call such a heterogeneous group a style, was extended far beyond its simple origin.

The reader is urged to forget the ceramic horrors to be seen in many an antique shop, and to look at the first-quality wares exhibited here. There is a world of difference. This difference is mainly due to market forces; the greatest demand for Satsuma from foreigners was for the cheapest and gaudiest. But it is the fine (and, when they were made, expensive) wares by the best of the potters and decorators with which we are concerned here.

Many of the Satsuma potters other than those of Kyoto were, in fact, decorators only; they bought in glazed blanks from pottery kilns that they then decorated and refired in a muffle kiln. Shapes were, of course, specially made to order by the potters. No doubt, though we lack precise information, the decorators would form some sort of connection with a particular pottery workshop.

The Satsuma artist best represented in the present Collection is Yabu Meizan (1853–1934).[2] Meizan served his apprenticeship in the pottery-painting workshops of Tokyo, setting up his own workshop in Osaka in 1880 (Figure 1). We can show no examples of this formative period. By the late 1880s he started to sell to foreign clients and his export business began. At this time his work mostly depicted Chinese figures and simple diaper patterns. Examples of this second period, the late 1880s, are Nos. 39 and 40. The diaper pattern characteristic of this period is best seen here on the shoulders and around the base of vases. Interestingly, this same pattern also appears in the work of another artist who used the name Meizan (see No. 77), but appears to have been a different person.

Yabu Meizan is first recorded as exhibiting abroad at the International Exposition of Paris in 1889, and at home at the Third National Industrial Exposition in 1890, where he won an award for 'Painting of a farmhouse on a vase', judged to be 'a pleasant design in a harmonious style'.[3] He was a regular exhibitor thereafter, at Chicago (1893), Paris (1900), St Louis (1904), Liège (1905), London (1910), and San Francisco (1915). He also exhibited at the Fourth and Fifth National Industrial Expositions of 1895 and 1903, and many other domestic exhibitions until 1916. From 1893 he was on the Japanese selection and preparation committee of most of the important international and domestic exhibitions; in the course of these duties he visited the exhibitions in Paris (1900), St Louis (1904), and London (1910).

Figure 2.
No. 6 of the works by Yabu Meizan illustrated in plate LV of Glendining's sale catalogue of the Tomkinson Collection, third portion, 26–8 June 1922

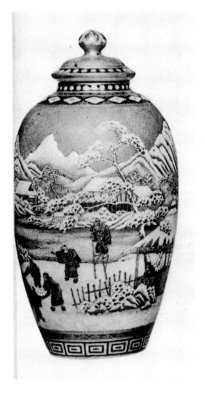

13

Figure 3.
Earthenware bowl
by Yabu Meizan
exhibited in St Louis
in 1904. Courtesy of
the Walters Art
Gallery, Baltimore

In Yabu Meizan's third period, from about 1890 to 1900, the designs diversify, and more Japanese (as opposed to Chinese) subjects are depicted. Geometric designs are less important and become smaller. Examples of the third period shown here are Nos. 41, 42, and 45. Slightly later are Nos. 48, 49, 55, and 56. These pieces can be compared with several examples of the work of Yabu Meizan described in the Michael Tomkinson Collection catalogue of 1898 and subsequently published as

plates LV and LVI in the third portion of the sale catalogue of his collection by Glendining (1922)[4] (Figure 2). We can therefore be fairly sure of their date (but see below).

Up until this point all of Yabu Meizan's works were signed with a seal-mark written in gold on a white ground; from this time, c.1900, all his pieces are signed with the seal in gold on a different gold ground.

In the fourth period, Yabu Meizan's most productive, the decoration of many of the best pieces consists of small figures, often in great numbers, at festivals or such, usually in panels. Other pieces have a landscape decoration of great detail and with typical Japanese scenes. The borders are very densely filled and may be totally made of large flowers, including peonies (see Nos. 57 and 59); he exhibited such pieces in the Fifth National Industrial Exposition in 1903. During this period panels tend to disappear and the scenes are more usually all around the vessel; a piece of this type, without panels, was exhibited at

Figure 4.
Vase by Yabu Meizan
illustrated in the
catalogue of the
Japan–British Exhibition
of 1910, No. 147

St Louis in 1904, and is now in the Walters Art Gallery, Baltimore (Figure 3, and see Nos. 62 and 63), while landscapes have a more Western form of perspective (No. 66). Borders are usually smaller and may disappear, at least around the rim of a vessel.

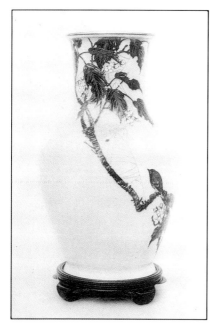

In the fifth period, after 1910, things change radically. At the Japan–British Exhibition in that year Yabu Meizan exhibited a vase in an almost totally different style (Figure 4);[5] in fact the painting style had been found used in the borders of some earlier pieces. Here the whole vase is taken over by a single, understated scene of a bird among maple-branches hunting a spider. Thereafter the scenes become even more open; this was, in fact, in keeping with the same tendency among other artists in different media, though, as with his contemporary Kinkozan (see below), a little late.

The difficulty with tracing the evolution of Yabu Meizan's style has been compounded by his retention of early works that he exhibited long after their manufacture. Thus, in the Japan–British

Exhibition in 1910 he exhibited a bowl (similar to No. 71) from the fourth period (Figure 5) alongside the new style of the fifth. The new-style vase was awarded a prize, but was subsequently sold for only £2. 10s.; the out-of-date bowl was sold for £25.[6] Clearly the buying public wanted evidence of painstaking work rather than 'good taste'. This retention of his own work is best demonstrated by consideration of the pieces in the Baur Collection, Geneva; these, with examples of most periods, were bought *en bloc* from the family as late as 1934.[7]

Japanese decorative arts at the very end of the nineteenth century were going through a particularly interesting period. Yabu Meizan, as we have seen, was affected by contemporary changes in style, but affected remarkably late. In metalwork, cloisonné, and lacquer as well as in most ceramic decoration, a new openness to design was appearing, a forsaking of the earlier cartouches, frames, and borders that had hitherto so restricted designs and destroyed scale; objects tended now to begin to be thought of as an entity, a complete work, rather than a surface to be cleverly decorated.[8]

The work of Yabu Meizan forms the major part of the earthenware in the Collection; however, other Satsuma artists who at their best made equally fine (but different) works are also represented. Yabu Meizan's work was all of a very high standard, and he was consequently much imitated. Most other Satsuma potters tended to cater to several levels of the market, and therefore their work is less consistently of a high quality. We know regrettably little of these potters, decorators, or companies, though for Kinkozan see below.

We have already noticed the work of the other potter who used the name Meizan. The figures on his wares are markedly different from those of Yabu Meizan, hence the consciousness of his identity. Otherwise, he seems to have followed the styles of Yabu Meizan (as, indeed, did many other Satsuma decorators), even in the method of the depiction of snow scenes (see No. 79, and compare it with No. 46 by Yabu Meizan). Of the work by Seikozan, the earliest here is probably No. 81; later (see No. 83) he used distinctly Western perspective, with minute detailing. Somewhat similar is the work of Nakamura Baikei, always with a long self-laudatory inscription on the base, who only produced fine wares (No. 87). This Westernizing tendency is also visible in the work of Kizan (No. 94), where the apparently classical scene on the *kakemono* has a strong Western touch, particularly in the depiction of the waves. At the same time, Makuzu Kozan's studio probably continued to make Satsuma earthenwares (see No. 27) even while making innovative porcelain.

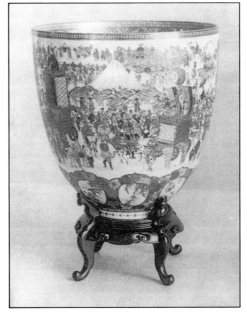

Figure 5.
Bowl by Yabu Meizan illustrated in the catalogue of the Japan–British Exhibition of 1910, No. 146

The Kyoto potters of Awata and Kiyomizu who followed the Satsuma style made their own ceramic bodies as well as decorating (contrast Yabu Meizan). One of the better makers was Kobayashi Sobei (1867–1927), the fifth of the family to use the studio-name Kagiya and the *go* Kinkozan. Kinkozan became the name of his factory in the Meiji period, which was much praised by Frank Brinkley in 1904.[9] Like the products of many Kyoto potters, much of Kinkozan V's work consisted of landscape enclosed by elaborate borders. In the case of the best or exhibition pieces, individual painters signed the scenes with their *go* or art-names. We know very little of these painters. On one of the finest of Kinkozan's pieces, No. 95, the panels are signed by Sozan. This is a particularly interesting piece, as it can be dated accurately to 1908, when it was commissioned by a G. Kobayashi of Kyoto as a gift to Mr James Robinson, a business associate.[10] This is not only unusually large, but extremely well painted—it was a handsome present.

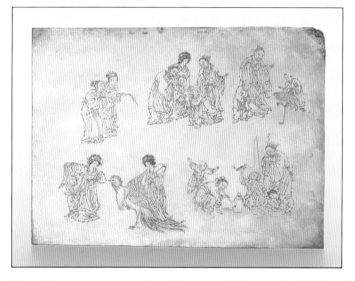

Figure 6.
Stencil of copper showing preliminary designs. Courtesy of Yamazaki Tsuyoshi and the Yabu family

One of the most startling of the painters was the enigmatic Shoko Takebe (see No. 88), whose work is comparatively rare; there are fine examples in the Baur Collection in Geneva.[11] He specialized in small-scale depiction of scattered figures in vivid action-poses often with some unifying theme, here the effects of the wind-god opening his bag. He had some connection with an English dealer living in Japan, Thomas Blow, whose name appears in katakana beside the seal of the artist.

The introduction of Western technology, not only by the German chemist Gottfried Wagener,[12] but also by those Japanese potters who had visited the international exhibitions of the time, had ensured a greatly increased production. The use of plaster moulds and of metal stencils (Figure 6) had allowed a greater uniformity than hitherto. For the use of such a stencil see the vase by Yabu Meizan (No. 62). The coal-fired kiln was more economical than the wood-fired *noborigama*. Not all these 'improvements' were beneficial to the top range of the market, but they were important for the new mass production for Western markets.

One of the most versatile as well as innovative potters of Japan was Miyagawa 'Makuzu' Kozan (1842–1916), descendant of a long line of Kyoto potters.[13] At first a somewhat old-fashioned potter, in 1867 he moved to Mushiage, near Bizen, where he made tea-wares in the style of Ninsei as well as enamel-decorated

porcelain. He moved back to Kyoto about 1870, and then to Yokohama, where he went into partnership with his brother-in-law Suzuki Yasubei.

Yokohama was booming, as it was the treaty port where most foreigners in Japan resided; but it had no ceramic tradition. After a settling-down period, Kozan began to make Satsuma-style earthenware, often with applied modelling in high relief (a notable example with a hawk in high relief is in the Victoria and Albert Museum: Figure 7). Although these were very successful—Kozan won prizes at Philadelphia in 1876—Brinkley was later to describe them as 'specimens that disgrace the period of their manufacture and represent probably the worst aberration of Japanese keramic conception'.[14] He ceased to make such pieces in the early 1880s, and began to experiment with monochrome glazes in the manner of the Chinese; he was particularly successful in this, earning praise from all contemporary critics—even Brinkley—and was sometimes accused of faking Chinese pieces.

Brinkley, writing between 1896 and 1902, commented that Makuzu (and Seifu: see below) could 'produce porcelains that almost rank with choice *Kang-hsi* [Kangxi] specimens, though they have not yet mastered the processes sufficiently to employ them in the manufacture of wares of moderate price'.[15]

Towards the end of the 1880s Kozan had handed over the running of his business to his stepson, Hannosuke (Hanzan, 1854–1940), concentrating on the invention of new 'transmutation' and crystalline glazes, then under experimentation also at Sèvres and Copenhagen. As we know from an article in the Yokohama trade journal of 1907, at that time Hanzan was 'in charge of the whole of production and

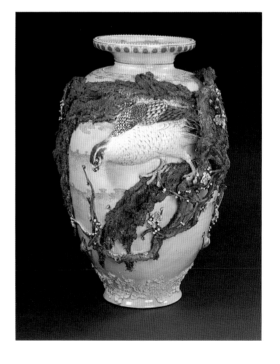

Figure 7.
Vase by Makuzu Kozan with a hawk in relief. Courtesy of the Trustees of the Victoria and Albert Museum

sales'.[16] The porcelain wares for which Makuzu Kozan is so celebrated (Figure 8) were, then, almost certainly the work of Hanzan, although signed with the name Makuzu Kozan. This is confirmed by the presence in the Collection of a piece of 'typical' Kozan porcelain most unusually signed 'Makuzu yo Hanzan sei', in very much the style of the contemporary signatures 'Makuzu Kozan sei'. The forms of the signatures provide clues to the dating of Hanzan's work; we shall follow these as indicators of changes in the style of his porcelain.

The early Kozan porcelain is represented in the Collection, but only one is shown here (No. 1); most of it is clumsy in outline and mediocre in decoration (judging by the highest standards, of course). These pieces are usually signed 'Kozan sei'. It is not difficult to see why the Makuzu Kozan Company was in poor shape in the early 1880s. Makuzu Kozan was made a Court Artist in 1896;

what we are suggesting is that this was for the work of the company, in fact the work of Hanzan. After Hanzan took over in the 1880s, there was a dramatic change in style; the shapes are more elegant and inventive and the decoration becomes increasingly sophisticated.

The first porcelains after the change, those of the late 1880s and early 1890s, have the mark written in clear calligraphy with no stylization; these are Nos. 3–7, of which the piece signed 'Hanzan' is No. 6. New colours have appeared: pink and green underglaze colours and the rich red-brown and yellow background colours. Possibly this may be due to assistance received from Gottfried Wagener.

In about 1900 (see No. 9) the character *ko* is stylized, looking rather like a cross; the next stage in the change involves the *san* character (of 'Kozan') also becoming stylized, and at a third stage the *sei* ('made by') becomes formal. This seems to be an evolutionary sequence towards the signature being written in imitation of a Chinese seal, at least by 1910 (see below).

After 1900 come the classic wares for which the name Makuzu Kozan is famous. The shapes are frequently unconventional but nearly always satisfying; occasional archaisms (see No. 14) are apparently contemporary with the grand blue-and-white and the sophisticated underglaze-decorated wares. These latter are now more often on a white ground than not; the brilliant coloured backgrounds are less frequent.

Figure 8.
The studio of
Makuzu Kozan,
*c.*1910.
Courtesy of the
Peabody–Essex
Museum, Salem

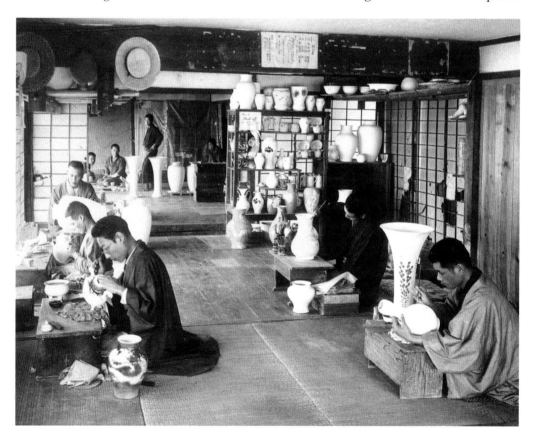

Occasionally a decoration that is almost a reference to the cloisonné enamel of Namikawa Sosuke can be seen (No. 11).[17] For a vase decorated with a nightingale in a plum-tree exhibited at St Louis in 1904, now in the Walters Art Gallery, Baltimore (Figure 9), he won a gold medal. At the Japan–British Exhibition in 1910 Makuzu Kozan exhibited the vase shown here as No. 19, surely made by Hanzan.[18] Interestingly, in the same exhibition Kozan showed a vase modelled with polar bears in an icicle-hung cave, now in the Victoria and Albert Museum, which is similar in modelling and glaze effects to the piece shown here as No. 26.[19] This must have been by the older Makuzu, who is known continually to have experimented with strange glaze effects. This is the same exhibition at which Yabu Meizan (see above) had also shown two pieces in markedly contrasting styles.

This 1910 vase (together with others of around this date) is signed with the signature written as if it were a Chinese seal-mark; in about 1915 the style of mark changes yet again, and it is now carefully written in a double circle. In 1910 Shugio[20] attributed all the work to Kozan, though commenting that Hanzan is also 'a very good potter'. We think Hanzan a very loyal son.

We have no record of Kozan ever travelling abroad. Hanzan visited (and exhibited at) many of the international exhibitions, notably that in Chicago in 1893, and had first-hand knowledge of Western ceramics; nevertheless, we attribute the distinctly Nordic-looking polar bears to Kozan, as quite out of keeping, as far as we can judge, with Hanzan's taste. Kozan was influenced by, and exerted an influence upon, the Royal Copenhagen Porcelain Manufactory, which was undergoing a period of inventive prosperity under the directorship of Arnold Krog.[21]

The majority of the porcelains in the Collection are by Makuzu Kozan (or Hanzan), but other distinguished contemporary potters are represented. Kato Tomotaro (1851–1916) began the Koishikawa factory in about 1900, using materials brought from Arita, Amakusa, and Seto, but had moved to Tokyo by 1904. Brinkley praises his blue-and-white as 'delicate and well finished'.[22] By 1910 he had progressed to coloured wares, for in that year he showed at the Japan–British Exhibition in London a vase closely similar to that shown here as No. 33.[23] Brinkley includes him (with Makuzu Kozan and Seifu Yohei) as one of the (seven) potters in Japan who devoted themselves 'wholly or in part to the new wares', these defined as 'a novel departure that distinguishes the present era'.[24]

Brinkley continues: 'among the seven keramists enumerated here, Seifu of Kyoto probably enjoys the highest reputation'. Seifu Yohei III (1851–1914) succeeded to

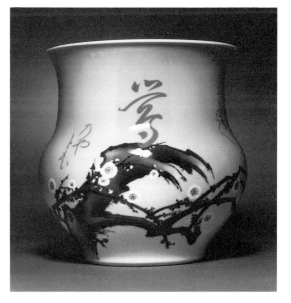

Figure 9.
Vase exhibited by Makuzu Kozan, though probably made by Hanzan, in St Louis in 1904. Courtesy of the Walters Art Gallery, Baltimore

the family business in Gojozaka in 1878. He is particularly celebrated for his ivory-white, and for decoration in delicate low-relief work in white, contrasting with a pale-coloured ground (see No. 29), but he also made brightly coloured wares, not all that dissimilar to those of Hanzan (see No. 28), and monochromes. Unlike Makuzu Kozan and most of the other potters who made monochromes, Seifu used the easier method of colours applied under a clear glaze, rather than coloured glazes (No. 30).

The potters Shofu Katei (see Nos. 35–7) and Suwa Sozan (No. 38) are mentioned in passing but not discussed by Shugio. Suwa Sozan (1851–1922) trained in Tokyo, but spent much of his time in Kutani, working in porcelain, until 1900, when he went to work for Kinkozan, finally setting up his own factory in Gojozaka in Kyoto in 1907.[25] He became well known for his low-relief modelling on porcelain and for his celadon. He exhibited at the Second National Industrial Exposition in 1881 and at the Japan–British Exhibition in 1910. He became a Court Artist in 1917. We have been unable to find any archive material on the Seishoen Company (No. 34).

The Meiji period was an interesting time of innovation in all the Japanese crafts. In some cases new styles seem to have continued too long, and in other cases degenerated into the cheap and mass-produced; but at their best Meiji crafts were inventive and above all demonstrated with enthusiasm the virtuosity of the artist.

The strength of the collection of ceramics shown here lies in the work of two artists. Makuzu Kozan—or, rather, his son Hanzan—was an adventurous potter with a great sense of style; Yabu Meizan, by contrast, was conservative, and his finely detailed work only broke free of the stifling borders and panels in about 1910. This was some time after a similar change had taken place in cloisonné enamel and in metalwork. But the high price achieved for the conservative bowl sold from the Japan–British Exhibition of 1910 demonstrates that there were buyers prepared to pay for such evidence of industry, even if it did not accord with the latest in taste. The 1910 exhibition must have been one of contrasts: Kozan showed his polar bears, related to our No. 26, Hanzan the blue-and-white vase shown here as No. 19. Yabu Meizan showed the bowl mentioned above similar to our No. 71, as well as the new-style vase with the spider and bird in a maple-tree, similar to our No. 75.

Notes

1. For an interesting account of a visit to the villages making these wares in 1877 see E. Satow, 'The Korean Potters in Satsuma', *Transactions of the Asiatic Society of Japan*, vol. 6, pt. 2 (1878), pp. 193–203. In the 1870s and 1880s there was some argument over the supposed early date of some of the large and gaudy Satsuma pieces that it is clear were quite modern.

2. For a fuller account of the life and work of Yabu Meizan see Yamazaki Tsuyoshi, 'Yabu Meizan (1853–1934)', in O. Impey and M. Fairley (eds.), *Meiji No Takara: Treasures of Imperial Japan*, vol. v. *Ceramics*, pt. 2. *Earthenware* (The Nasser D. Khalili Collection of Japanese Art; London [in press]).

3. *Meiji nijusannen, Dai sankai Naikoku Kangyo Hakurankai: Shinsa hokoku* [Meiji 23 (1890), the Third National Industrial Exhibition: Report of the judges] (Tokyo, 1890).

4. Michael Tomkinson, *A Japanese Collection* (2 vols.; London, 1898); Glendining and Co. Ltd., *Catalogue of the . . . Very Important Collection of Japanese Works of Art, Formed by the Late Michael Tomkinson Esq., of Franche Hall, Kidderminster, London* (London, 1921–2).

5. *An Illustrated Catalogue of Japanese Modern Fine Arts Displayed at the Japan–British Exhibition, London 1910* (Tokyo, 1910), No. 147.

6. H. Shugio, 'Japanese Art and Artists of To-day, II. Ceramic Artists', *The Studio*, vol. 50 (June 1910), pp. 286–93.

7. P.-F. Schneeberger, *Alfred Baur* (Geneva, 1989), p. 75.

8. For a discussion of this see O. Impey and M. Fairley, 'Introduction', in O. Impey and M. Fairley (eds.), *Meiji No Takara: Treasures of Imperial Japan*, vol. i. *Selected Essays* (The Nasser D. Khalili Collection of Japanese Art; London, 1995).

9. F. Brinkley, *Japan: Its History, Arts and Literature*, vol. viii. *Keramic Art*, British edn. (London and Edinburgh, 1904), p. 196.

10. Manuscript letter from G. Kobayashi to James Robinson, 1908, in the possession of Dr Nasser D. Khalili.

11. See J. Ayers, *The Baur Collection, Geneva: Japanese Ceramics* (Geneva, 1982), Nos. E112 and E113.

12. For an account of the work of this most energetic and influential scientist see G. Avitabile, 'Gottfried Wagener (1831–1892)', in Impey and Fairley (eds.), *Meiji No Takara*, vol. i.

13. For an account of the life and work of Makuzu Kozan and his son Hanzan see C. Pollard, 'Miyagawa Kozan (1842–1916)', in O. Impey and M. Fairley (eds.), *Meiji No Takara: Treasures of Imperial Japan*, vol. v. *Ceramics*, pt. 1. *Porcelain and Stoneware* (The Nasser D. Khalili Collection of Japanese Art; London [in press]).

14. Brinkley, *Japan*, vol. viii, p. 416.

15. Ibid., p. 418.

16. *Yokohama boeki shimpo* [Yokohama trade journal] (16 May 1907).

17. See examples in O. Impey and M. Fairley (eds.), *Meiji No Takara: Treasures of Imperial Japan*, vol. iii. *Enamels* (The Nasser D. Khalili Collection of Japanese Art; London, 1995).

18. *An Illustrated Catalogue of Japanese Modern Fine Arts*, No. 155.

19. The V&A polar-bear vase from the Japan–British exhibition is illustrated in J. V. Earle (ed.), *The Toshiba Gallery: Japanese Art and Design* (London, 1986), fig. 181, p. 186.

20. Shugio, 'Japanese Art and Artists of To-day, II. Ceramic Artists', p. 286.

21. For a discussion of this see V. Woldbye, 'Ceramic Interplay: Copenhagen and Japan during the 1880s and 1890s', in Impey and Fairley (eds.), *Meiji No Takara*, vol. v/1.

22. Brinkley, *Japan*, vol. viii, p. 394.

23. *An Illustrated Catalogue of Japanese Modern Fine Arts*, No. 163, where it is included in error among the cloisonné enamels.

24. Brinkley, *Japan*, vol. viii, p. 417.

25. Raku Bijutsukan [Raku Museum] and Sado Shiryokan [Sado Research Institute], *Kyoto no kindai kogei: Togei to shitsugei* [Modern art in Kyoto: Ceramics and lacquer] (Kyoto, 1994), pp. 99–100.

Makuzu Kozan

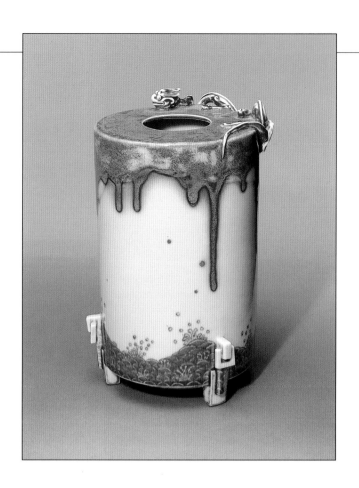

1. Porcelain vase by Makuzu Kozan
modelled with a dragon, with flambé
glaze and underglaze blue waves
Signed Kozan sei
1880s 21.6 cm.

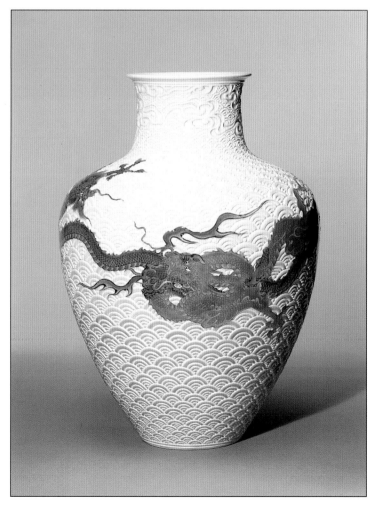

2. Porcelain vase by Makuzu Kozan,
with two rain-dragons in underglaze
blue and aubergine, on a ground of
stylized waves, glazed in high relief,
the neck carved with clouds
Signed Dai Nihon Kozan sei
1890s 37.6 cm.

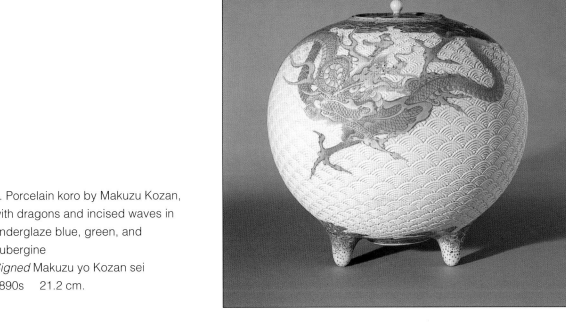

3. Porcelain koro by Makuzu Kozan, with dragons and incised waves in underglaze blue, green, and aubergine
Signed Makuzu yo Kozan sei
1890s 21.2 cm.

4. Porcelain shallow bowl by Makuzu Kozan, the interior incised with fish, the exterior enamelled with ho-o motifs on a coral ground
Signed Makuzu yo Kozan sei
1890s Dia. 21 cm.

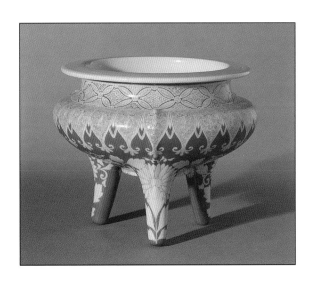

5. Porcelain koro by Makuzu Kozan, enamelled with formal flower design beneath a brocade border
Signed Kozan sei
1890s 13.2 cm.

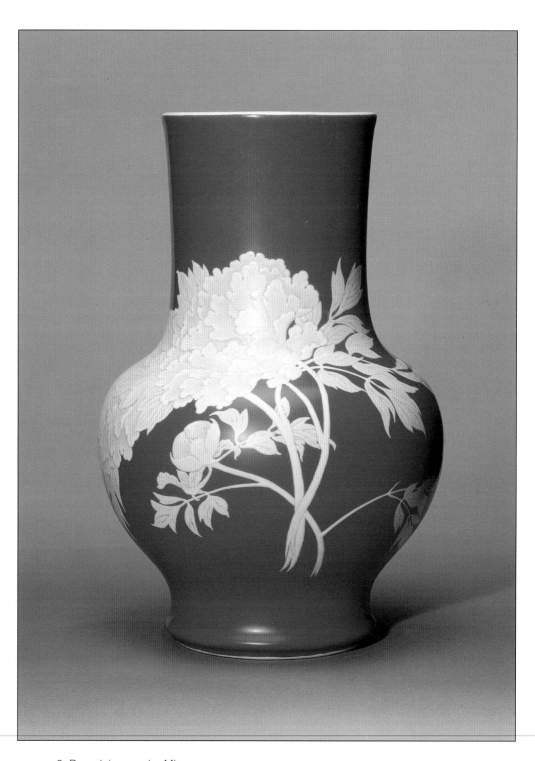

6. Porcelain vase by Miyagawa
Hanzan (Makuzu Kozan II),
enamelled with peonies on a
coral ground
Signed Makuzu yo Hanzan sei
1890s 32.5 cm.

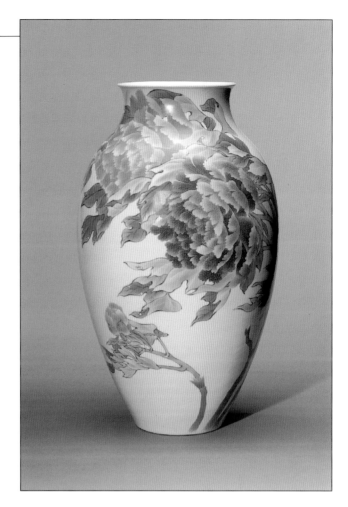

7. Porcelain vase by Makuzu Kozan, with wind-blown peonies in underglaze blue, dark blue, aubergine, green, and yellow, on a yellow ground
Signed Makuzu yo Kozan sei
1890s 47 cm.

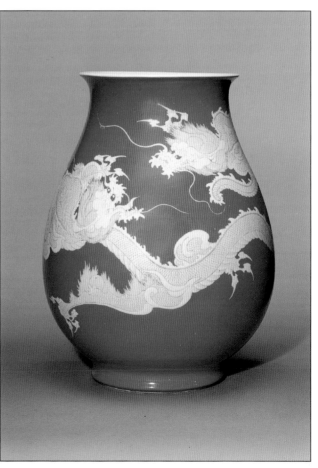

8. Porcelain vase by Makuzu Kozan, with two rain-dragons enamelled in pale yellow on a coral ground
Signed Makuzu yo Kozan sei
1895–1900 38.8 cm.

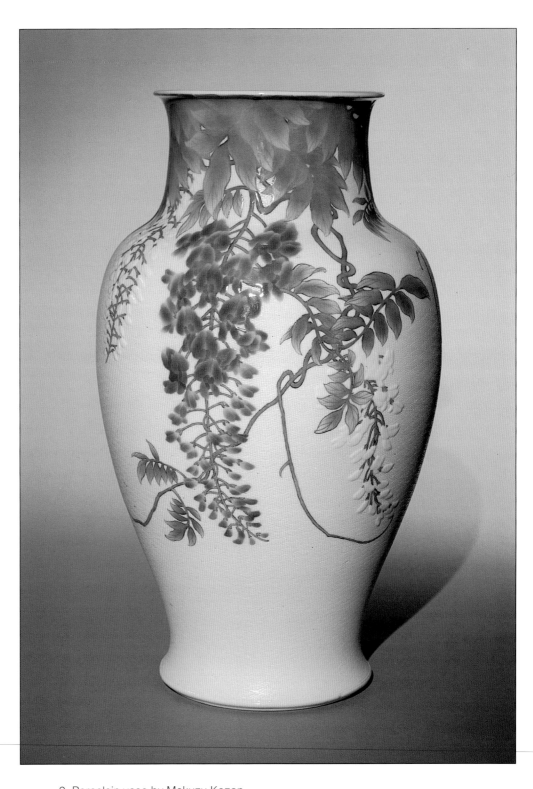

9. Porcelain vase by Makuzu Kozan,
with trailing wistaria in underglaze
purple and green and white enamel
on a lightly incised wave ground
Signed Makuzu Kozan sei
*c.*1900 36.7 cm.

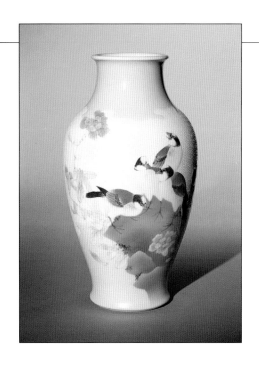

10. Porcelain vase by Makuzu Kozan, with finches and flowers in underglaze blue, green, aubergine, yellow, and black, on a lightly incised wave ground
Signed Mazuku Kozan sei
*c.*1900 21.5 cm.

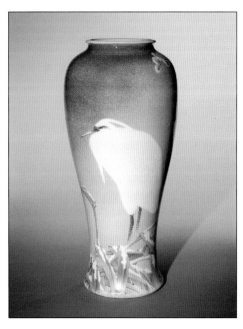

11. Porcelain vase by Makuzu Kozan, with an egret beside snow-covered grasses in underglaze white, black, and green on a graduated blue and grey ground
Signed Makuzu Kozan sei
*c.*1900 29.7 cm.

12. Porcelain vase by Makuzu Kozan, in the form of a lotus-flower decorated in underglaze blue, aubergine, and yellow
Signed Makuzu Kozan sei
*c.*1900 15.2 cm.

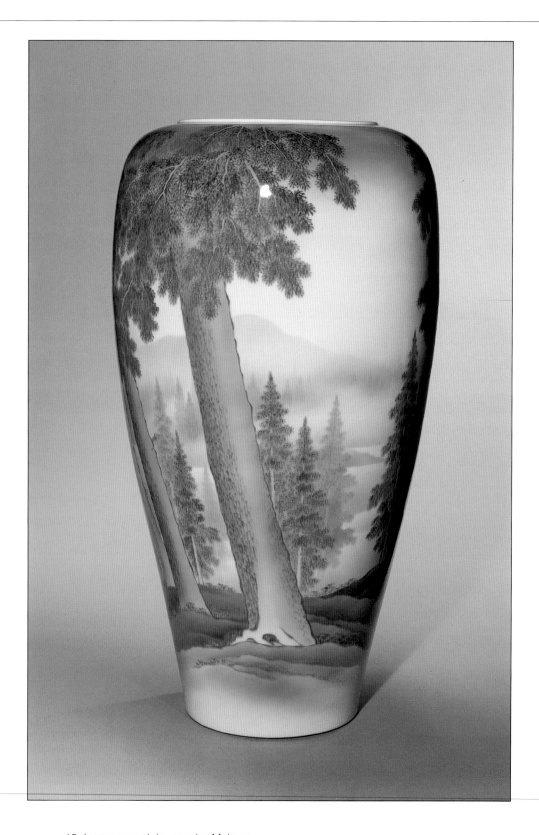

13. Large porcelain vase by Makuzu
Kozan, with pine-trees beside a lake
in a mountainous landscape, in
underglaze blue
Signed Makuzu Kozan sei
1905–15 60.5 cm.

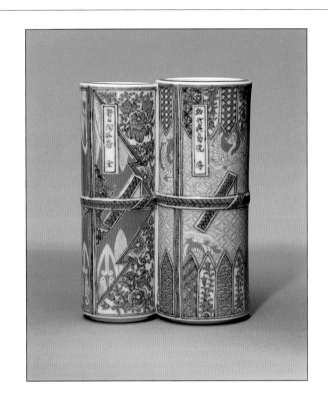

14. Porcelain double vase in the form of two *makimono* , one inscribed *Shodai Makuzu yaki den* [History of the kiln of Makuzu the First], the other *Kozan tojiki zen* [Complete scroll of Kozan porcelain], decorated in underglaze blue and yellow enamel on a coral ground
Signed Makuzu Kozan sei
*c.*1900 19 cm.

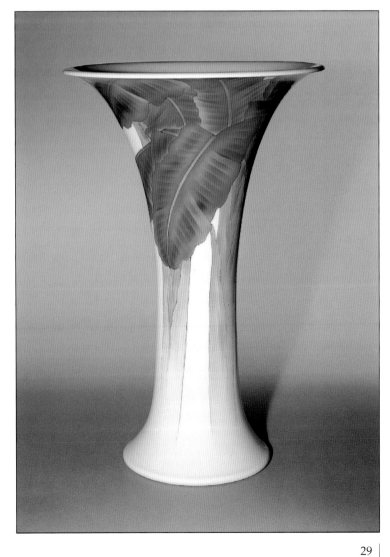

15. Porcelain trumpet-vase by Makuzu Kozan, with stems of banana-leaves in underglaze blue
Signed Makuzu Kozan sei
*c.*1905–15 42.5 cm.

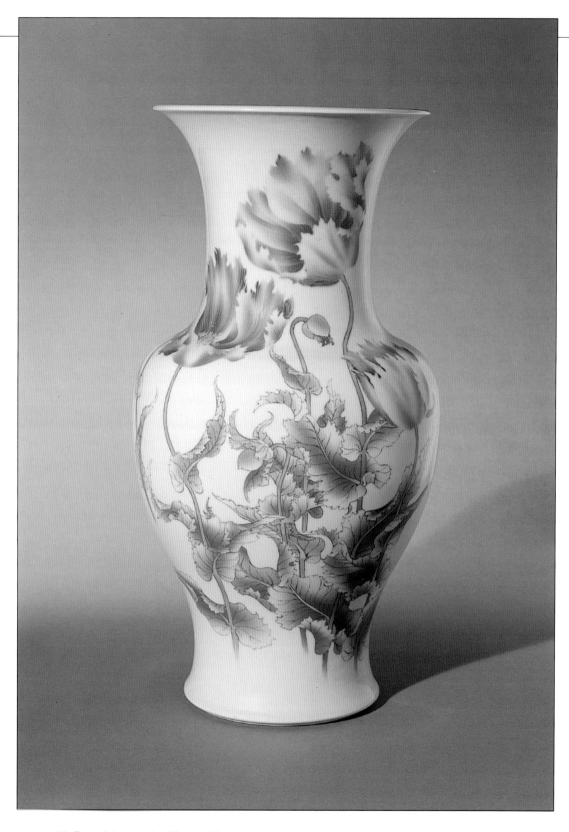

16. Porcelain vase by Makuzu Kozan,
with leafy stems of poppies in
underglaze blue, aubergine, and
green, with slight details in yellow
and white enamel
Signed Makuzu Kozan sei
*c.*1900 42 cm.

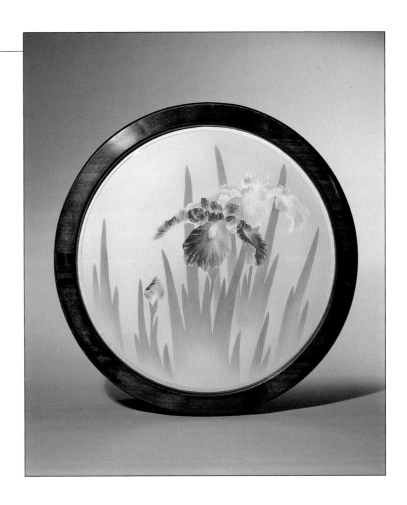

17. Porcelain plaque with stems of irises in underglaze blue, purple, yellow, and green
Signed Makuzu Kozan sei
*c.*1910 Dia. 41.2 cm.

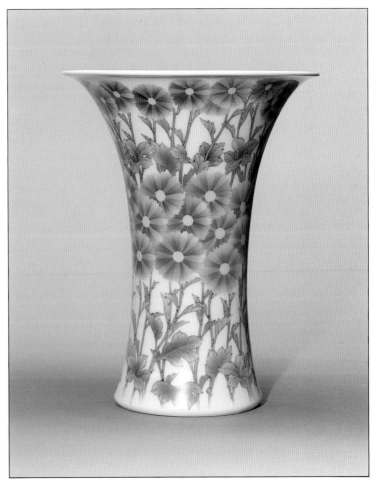

18. Porcelain trumpet-vase with a formal design of chrysanthemum-stems, in underglaze blue and yellow
Signed Makuzu Kozan sei
*c.*1910 30.5 cm.

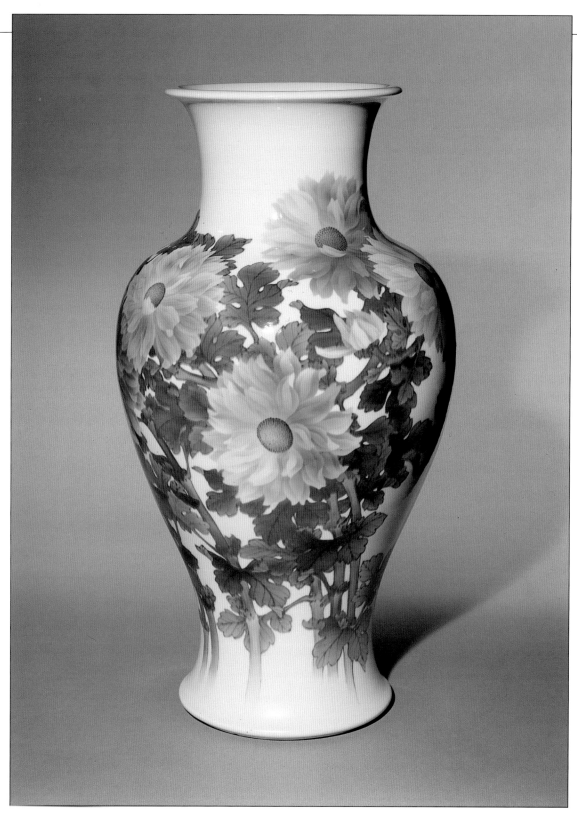

19. Porcelain vase by Makuzu Kozan, with
flowering chrysanthemums in underglaze blue
Signed Makuzu Kozan sei
*c.*1910 52.7 cm.

Exhibited at the Japan–British Exhibition, London, 1910,
and illustrated in the official catalogue (Tokyo, 1910), No. 155

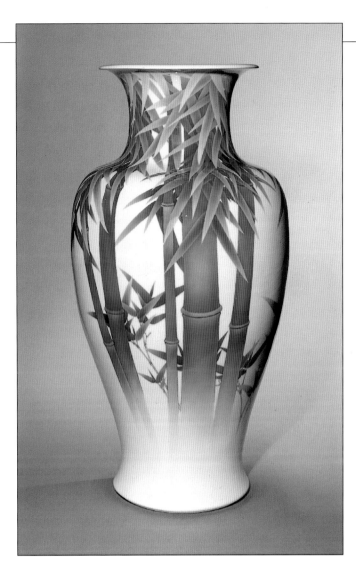

20. Large porcelain vase by Makuzu
Kozan with numerous leafy bamboo-
stems in underglaze blue
Signed Makuzu yo Kozan sei
*c.*1910 68.3 cm.

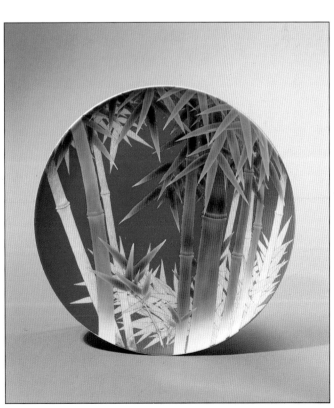

21. Porcelain plate by Makuzu Kozan,
with numerous leafy bamboo-stems in
underglaze blue and yellow enamel
on a coral ground
Signed Makuzu yo Kozan sei
*c.*1910 Dia. 38.7 cm.

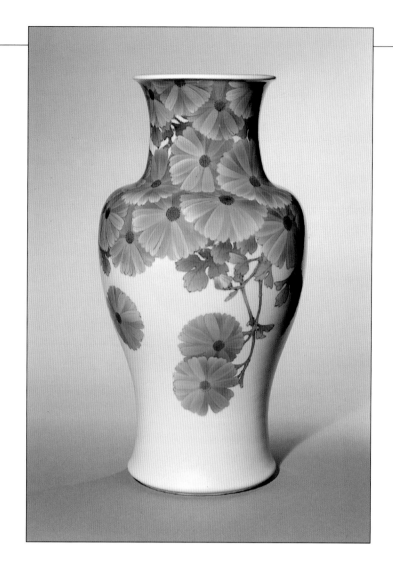

22. Porcelain vase by Makuzu Kozan,
with trailing stems of
chrysanthemums in underglaze blue
on an enamelled yellow ground
Signed Makuzu Kozan sei
*c.*1915 37 cm.

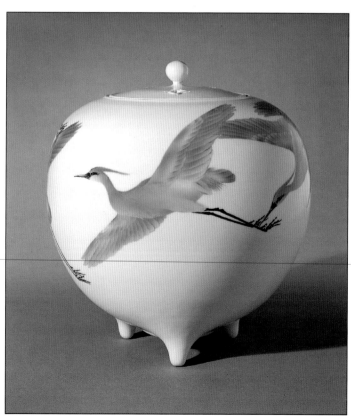

23. Porcelain koro by Makuzu Kozan,
with numerous cranes in flight in
underglaze blue and black
Signed Makuzu Kozan sei
*c.*1915 24.2 cm.

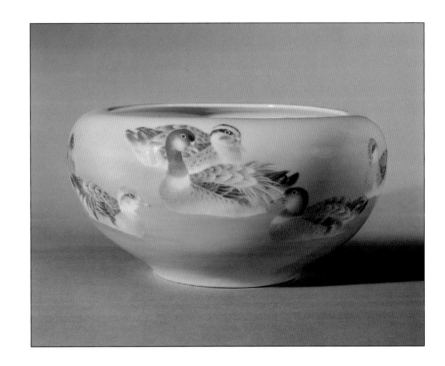

24. Porcelain bowl by Makuzu Kozan,
with numerous ducks on water in
underglaze blue
Signed Makuzu Kozan sei
*c.*1915 Dia. 32.4 cm.

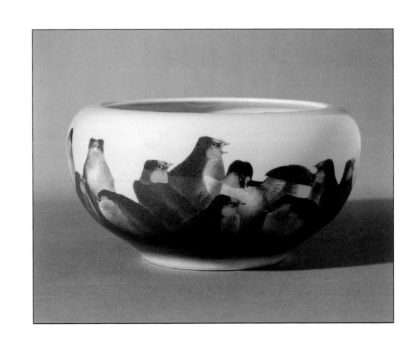

25. Porcelain bowl by Makuzu Kozan,
with numerous sea-birds in
underglaze black and aubergine, the
interior with cherry-blossom in
underglaze aubergine
Signed Makuzu Kozan sei
*c.*1915 Dia. 20.6 cm.

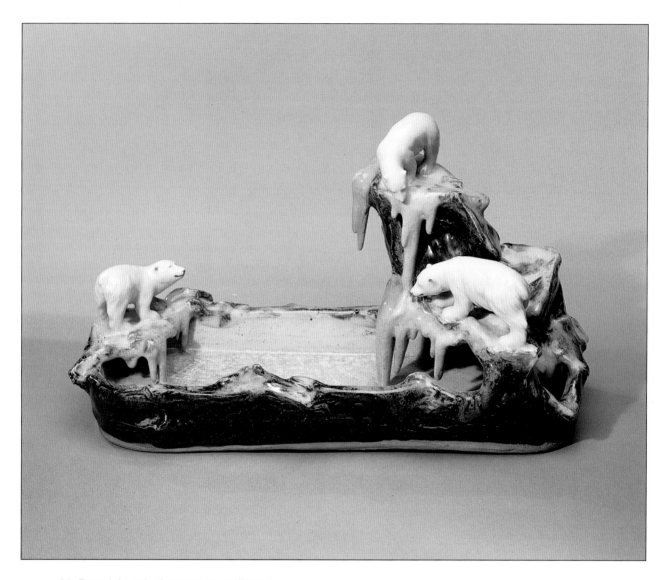

26. Porcelain polar-bear group attributed
to Makuzu Kozan, naturalistically modelled
with three bears on rocks above a frozen pool,
in underglaze turquoise and brown
Unsigned
*c.*1910 21.9×38.5 cm.

For a similar example in the Victoria and Albert Museum (inv. No. C.244-1910)
see J. V. Earle (ed.), *The Toshiba Gallery: Japanese Art and Design* (London,
1986), fig. 181, p. 186

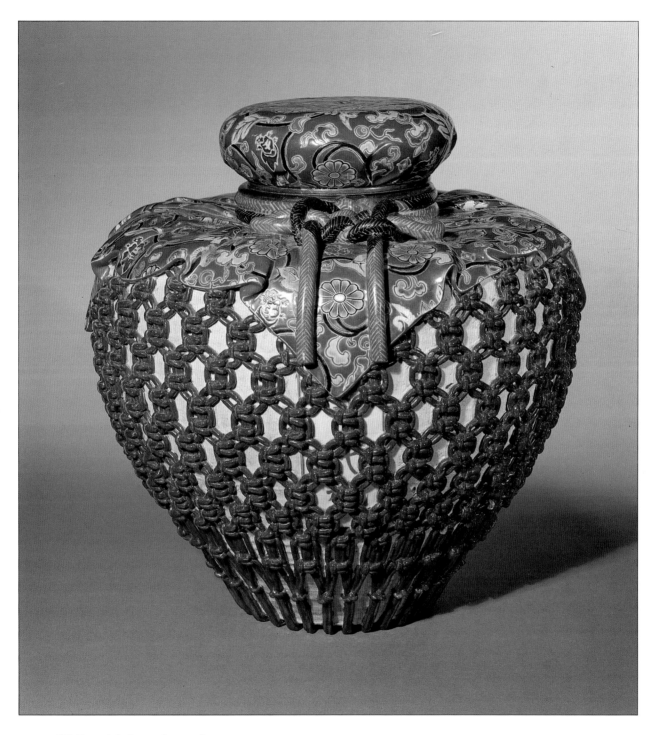

27. Porcelain jar and cover by
Makuzu Kozan, modelled with a
brocade cloth over the cover and
shoulder, tied with tasselled cords,
the body enclosed within knotted
canework
Impressed seal Makuzu
1910–15 35.6 cm.

Seifu Yohei III

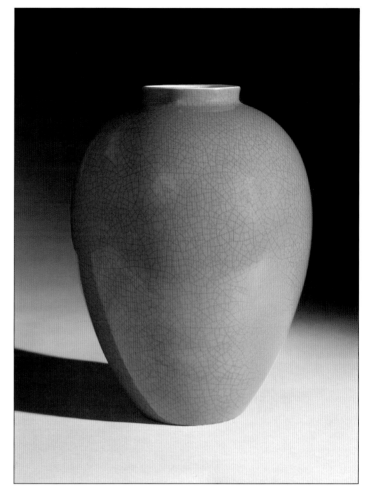

28. Earthenware vase by Seifu
Yohei III, with a crackled orange
monochrome glaze
Signed Dai Nihon Seifu zo
*c.*1890 28 cm.

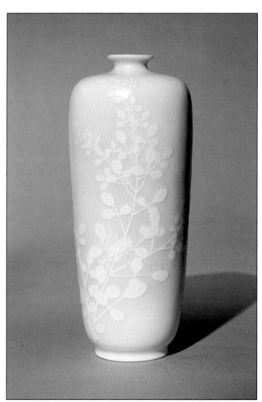

29. Porcelain vase by Seifu Yohei III,
decorated in low relief with *hagi* on a
cream ground
Signed Seifu
*c.*1900 17.7 cm.

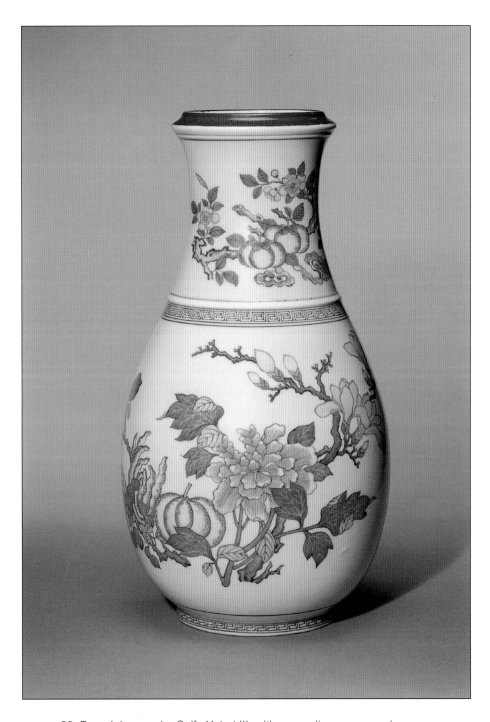

30. Porcelain vase by Seifu Yohei III, with magnolia, peony, and
narcissus flowers, pumpkin, and finger-citron, the neck with
persimmons, *uri*, cherry-blossom, and *reishi* fungus, in underglaze
blue on an enamelled yellow ground
Signed Dai Nihon Seifu zo
1890s 37 cm.

Inoue Ryosai

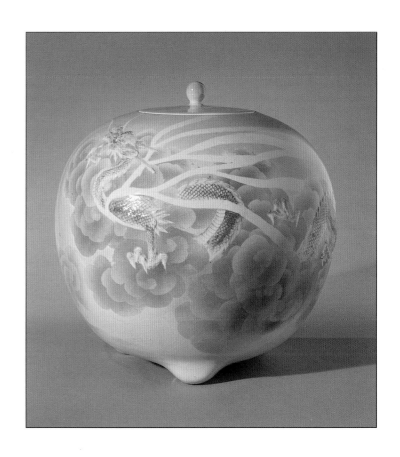

31. Porcelain koro by Inoue Ryosai,
modelled in relief with a dragon
among clouds, in underglaze green
and brown
Signed Inoue Ryosai
1890s 29.7 cm.

Tominaga Genroku

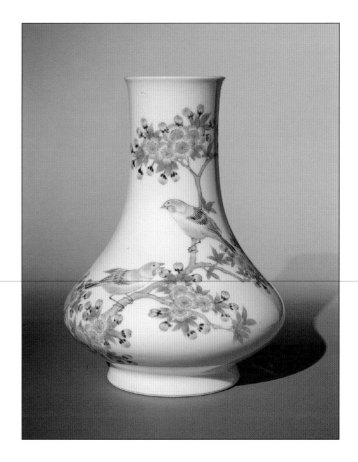

32. Porcelain vase by Tominaga
Genroku, with finches in flowering
cherry-branches, in underglaze blue,
red, and yellow
Signed Genroku sei
*c.*1900 25.3 cm.

Kato Tomotaro

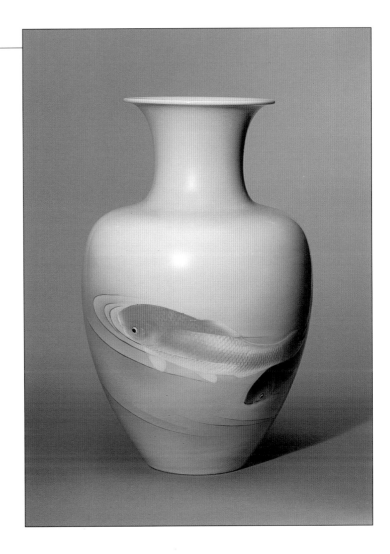

33. Porcelain vase by Kato Tomotaro, modelled in low relief with two carp in rippling water in orange and black on a graduated underglaze blue ground
Signed Yugyokuen Toju sei
*c.*1910 39.3 cm.

Seishoen

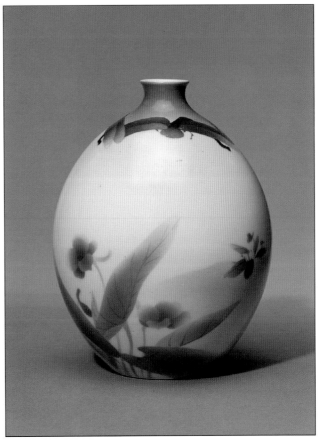

34. Porcelain vase by Seishoen, with lilies beneath a dragonfly border in underglaze green, pink, and black on a graduated blue and yellow ground
Signed Seishoen sei
*c.*1910 15.2 cm.

Shofu Katei

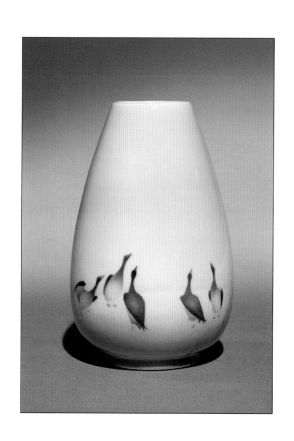

35. Porcelain vase by Shofu Katei,
with stylized geese in underglaze
black and red on a lightly graduated
underglaze pale-pink ground and
grey foreground
Signed Shofu
*c.*1910 12 cm.

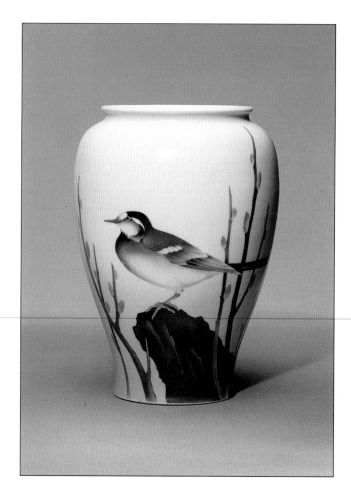

36. Porcelain vase by Shofu Katei,
with a wagtail on a rock in
underglaze blue, black, and green
on a graduated blue and pink ground
Signed Shofu
*c.*1910 18.5 cm.

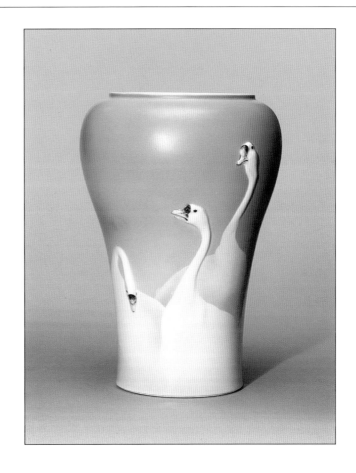

37. Porcelain vase by Shofu Katei,
modelled in relief with three geese on
a pale aubergine ground
Signed Shofu
*c.*1910 24.1 cm.

Suwa Sozan

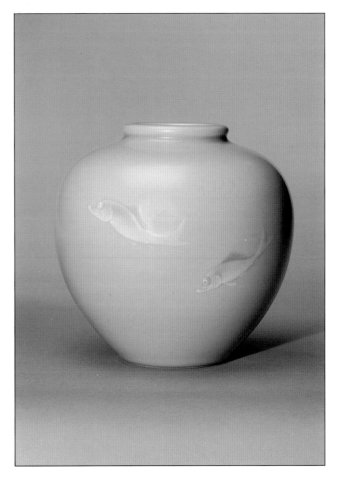

38. A celadon jar by Suwa Sozan,
decorated in low relief with a shoal of
fish in underglaze pink and black
Signed Suwa Sozan
*c.*1920 17.7 cm.

Yabu Meizan

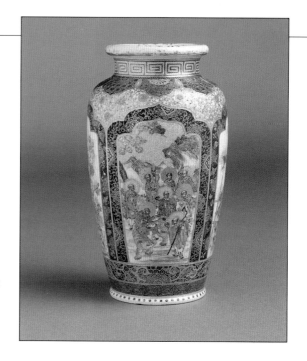

39. Earthenware vase by Yabu Meizan
Signed Meizan sei
*c.*1890 13.1 cm.

40. Pair of earthenware *natsume* by
Yabu Meizan
Signed Meizan sei
*c.*1890 7.7 cm.

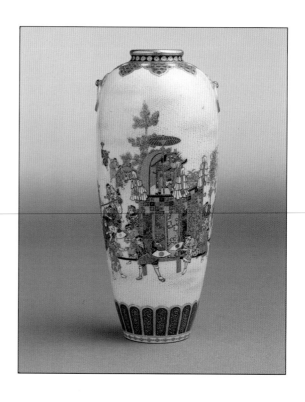

41. Earthenware vase
Signed Yabu Meizan
1890s 14.9 cm.

42. Earthenware bowl
Signed Yabu Meizan
1890s Dia. 12.5 cm.

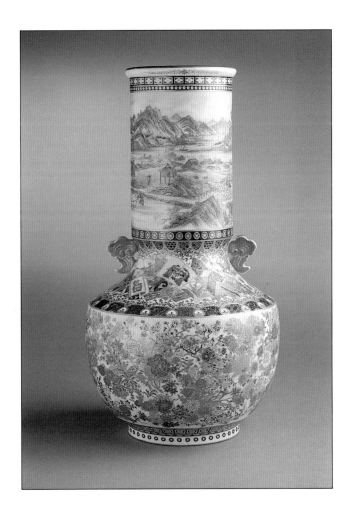

43. Earthenware vase
Signed Yabu Meizan
1890s 31.2 cm.

44. Earthenware koro
Signed Yabu Meizan
1890s 11 cm.

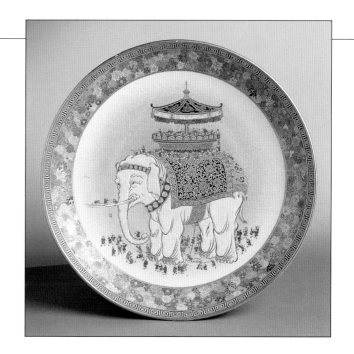

45. Earthenware plate
Signed Yabu Meizan
1890s Dia. 37.2 cm.

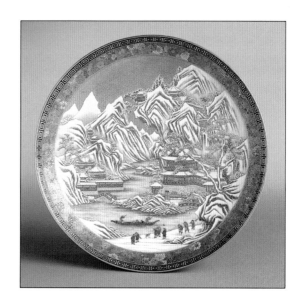

46. Earthenware plate
Signed Yabu Meizan
1890s Dia. 27.7 cm.

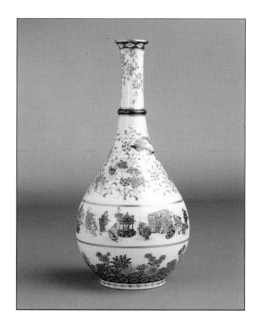

47. Earthenware vase
Signed Yabu Meizan
1890s 18.6 cm.

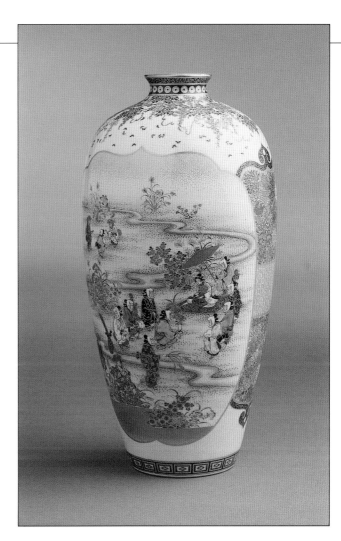

48. Earthenware vase
Signed Yabu Meizan
1890s 19.8 cm.

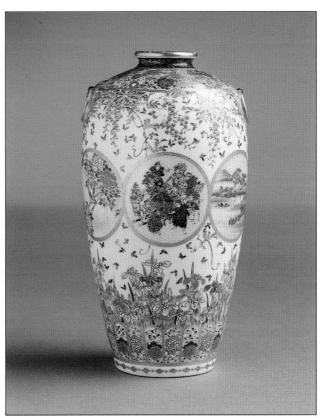

49. Earthenware vase
Signed Yabu Meizan
1890s 12.9 cm.

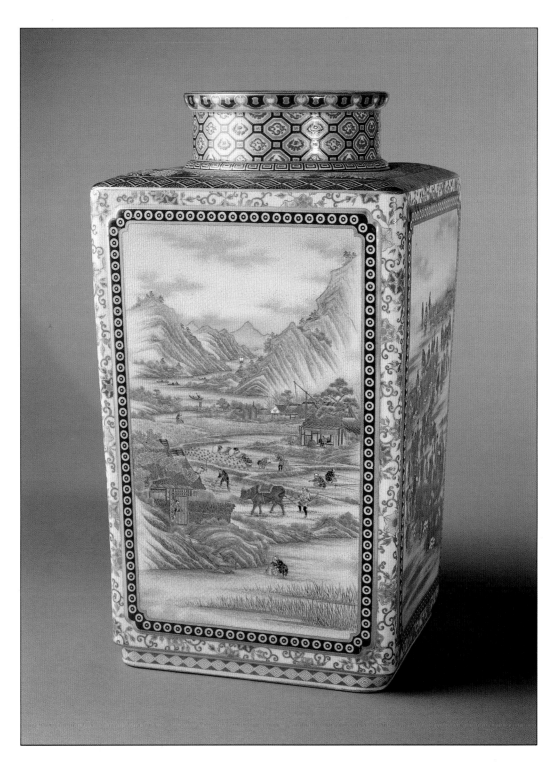

50. Earthenware vase
Signed Yabu Meizan
*c.*1900 37 cm.

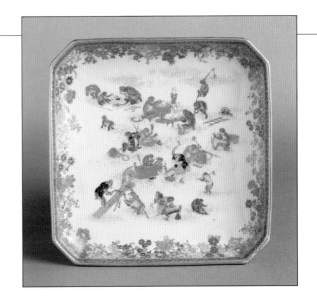

51. Earthenware plate
Signed Yabu Meizan
*c.*1900 Dia. 16.1 cm.

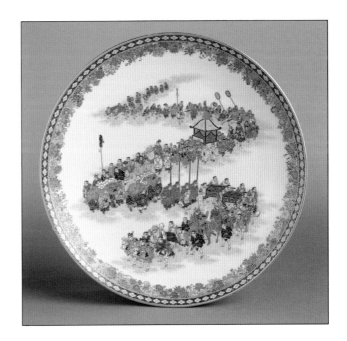

52. Earthenware plate
Signed Yabu Meizan
*c.*1900 Dia. 21.5 cm.

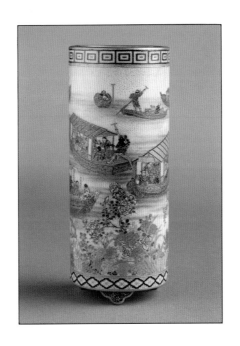

53. Earthenware brush-pot
Signed Yabu Meizan
*c.*1900 12.4 cm.

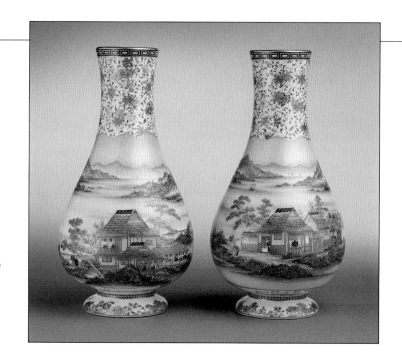

54. Pair of earthenware
vases
Signed Yabu Meizan
*c.*1900 24 cm.

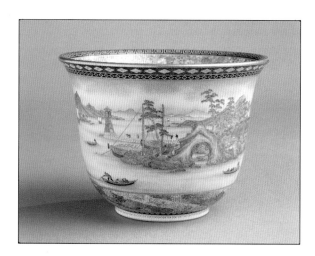

55. Earthenware bowl
Signed Yabu Meizan
*c.*1900 Dia. 17 cm.

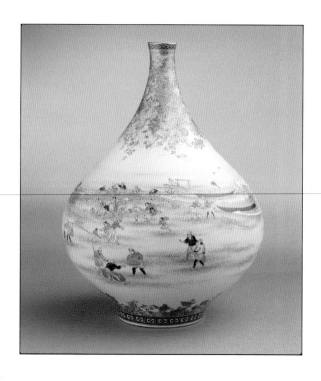

56. Earthenware bottle
Signed Yabu Meizan
*c.*1900 20.5 cm.

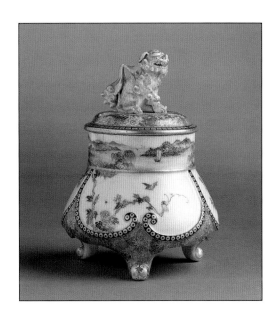

57. Earthenware koro
Signed Yabu Meizan
1900–10 16.5 cm.

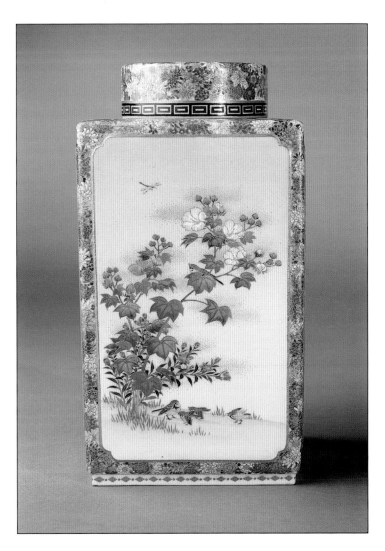

58. Earthenware tea-caddy
Signed Yabu Meizan
1900–10 19.8 cm.

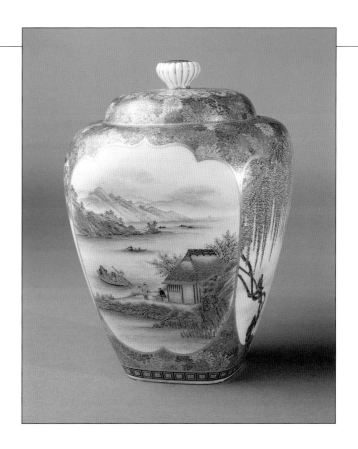

59. Earthenware jar
Signed Yabu Meizan
1900–10 17.8 cm.

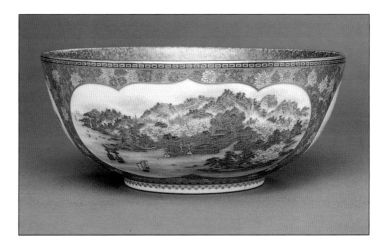

60. Earthenware bowl
Signed Yabu Meizan
1900–10 Dia. 18 cm.

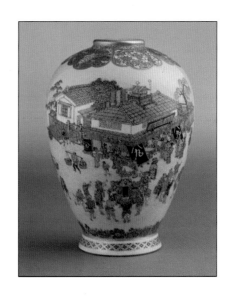

61. Earthenware vase
Signed Yabu Meizan
1900–10 10.7 cm.

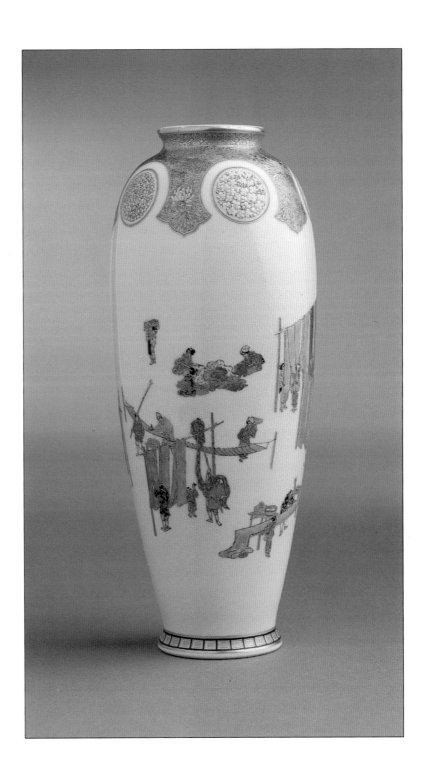

62. Earthenware vase
Signed Yabu Meizan
1900–10 18.1 cm.

The original copper design-plate for this vase is one of the collection of plates
still in the possession of the Yabu family, and is on display at the exhibition

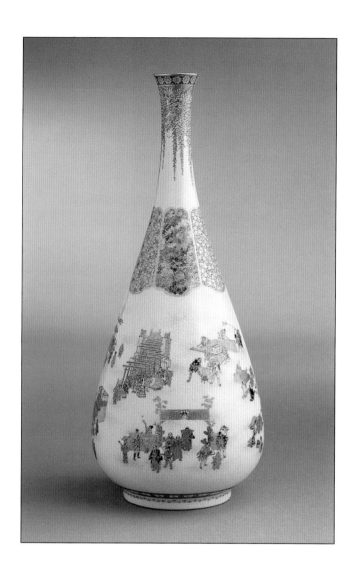

63. Earthenware vase
Signed Yabu Meizan
and impressed Meizan
1900–10 24.8 cm.

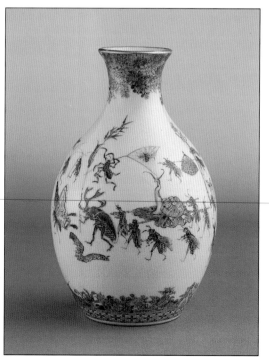

64. Earthenware vase
Signed Yabu Meizan
1900–10 11.7 cm.

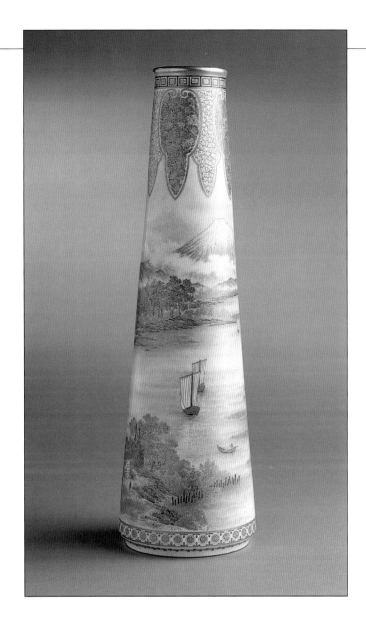

65. Earthenware vase
Signed Yabu Meizan
1900–10 29.5 cm.

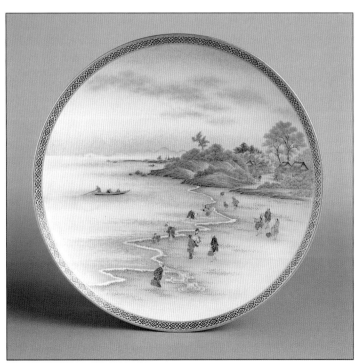

66. Earthenware plate
Signed Yabu Meizan
1900–10 Dia. 21.2 cm.

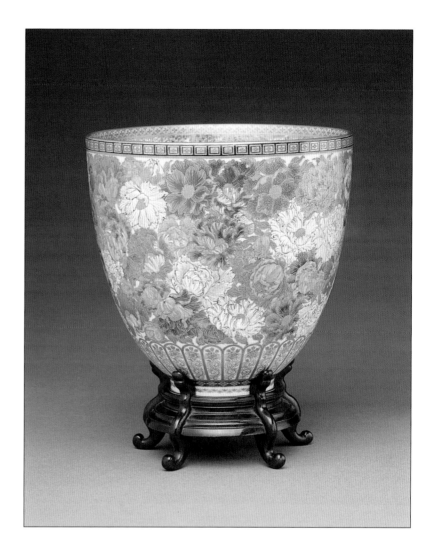

67. Earthenware bowl
Signed Yabu Meizan
and impressed Meizan
1900–10
H. 15 cm., Dia. 15.3 cm.

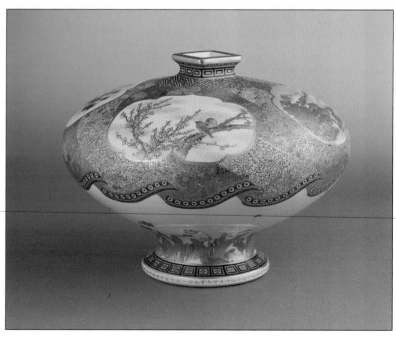

68. Earthenware vase
Signed Yabu Meizan
and impressed Meizan
1900–10 11.5 cm.

69. Earthenware bowl
Signed Yabu Meizan
1900–10 8 cm.

70. Earthenware koro
Signed Yabu Meizan
1900–10 8.2 cm.

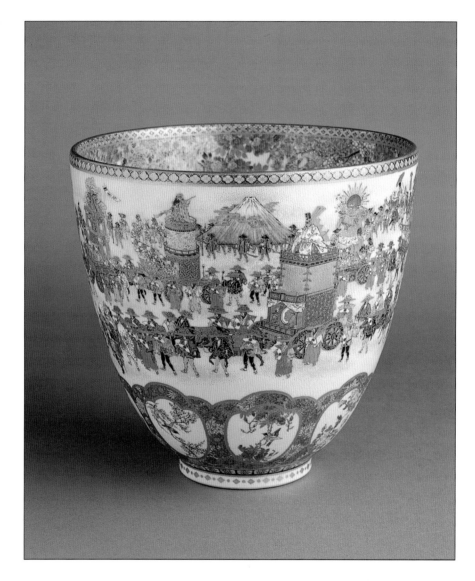

71. Earthenware bowl
Signed Yabu Meizan
1900–10
H. 15 cm., Dia. 15.8 cm.

An almost identical bowl was exhibited at the Japan–British
Exhibition, London, 1910, and illustrated in the official catalogue
(Tokyo, 1910), No. 146

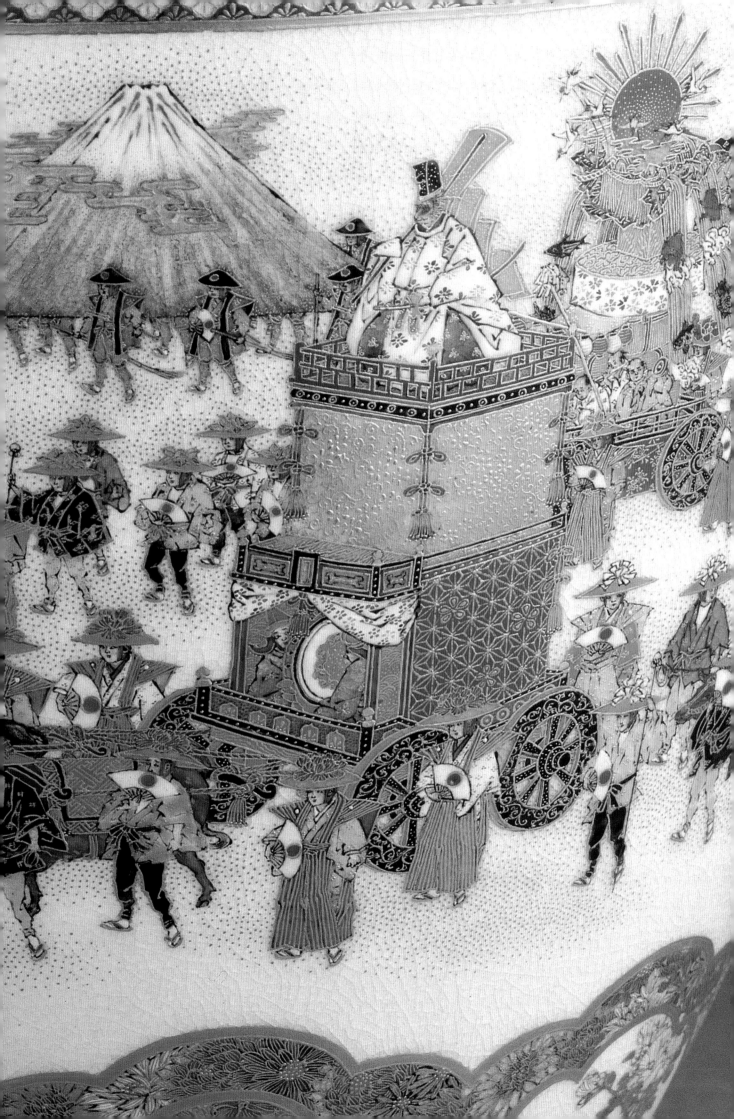

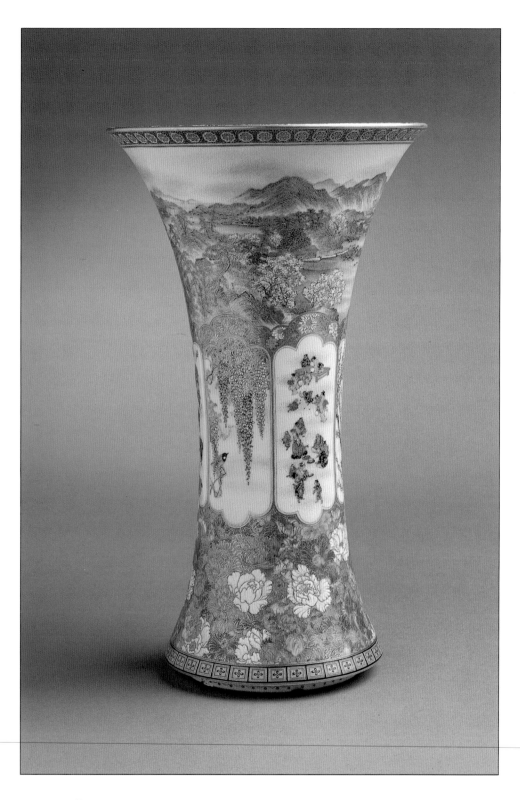

72. Earthenware trumpet-vase
Signed Yabu Meizan
1900–10 29.6 cm.

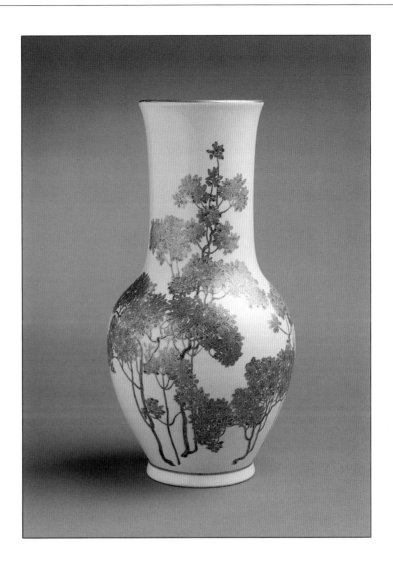

73. Earthenware vase
Signed Yabu Meizan
c.1915 21.7 cm.

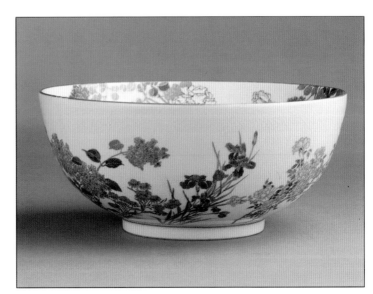

74. Earthenware bowl
Signed Yabu Meizan
c.1915 Dia. 17.8 cm.

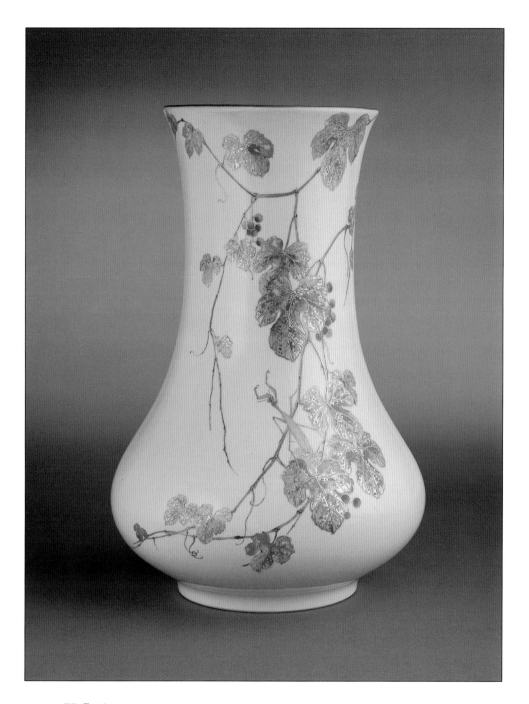

75. Earthenware vase
Signed Yabu Meizan
*c.*1910 25 cm.

A vase with a similar style of decoration was exhibited at the
Japan–British Exhibition, London, 1910, and illustrated in the
official catalogue (Tokyo, 1910), No. 147

76. Earthenware box
Signed Yabu Meizan
*c.*1915 Dia. 8 cm.

Meizan

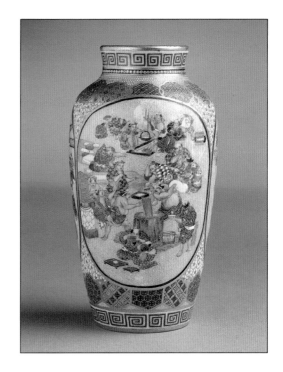

77. Earthenware vase
Signed Meizan sei
1890s 14.8 cm.

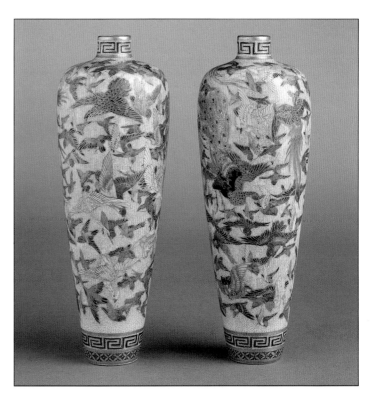

78. Pair of
earthenware vases
Signed Meizan
1890s 15 cm.

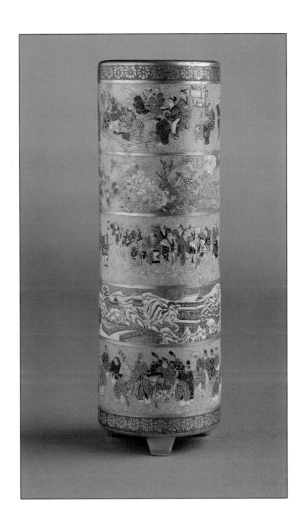

79. Earthenware vase
Signed Meizan sei
1890s 15.5 cm.

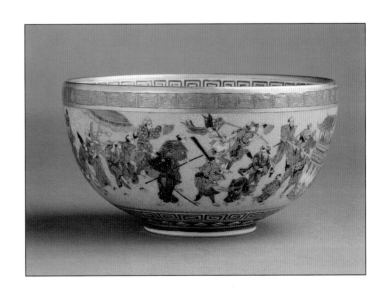

80. Earthenware bowl
Signed Meizan sei
1890s Dia. 12.5 cm.

Seikozan

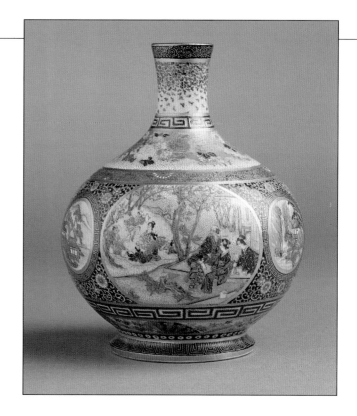

81.Earthenware vase
Signed Kozan sei
(Seikozan)
1890s 12.2 cm.

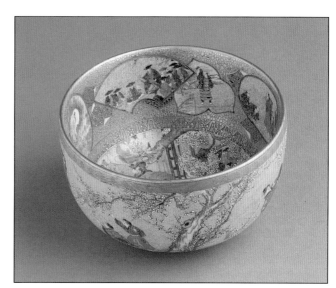

82. Earthenware bowl
Signed Seikozan
1890s Dia. 11 cm.

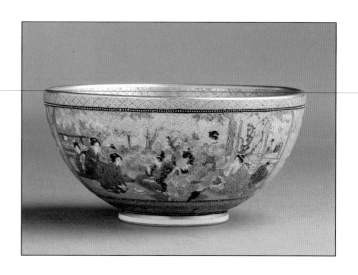

83. Earthenware bowl
Signed Seikozan
1890s Dia. 11 cm.

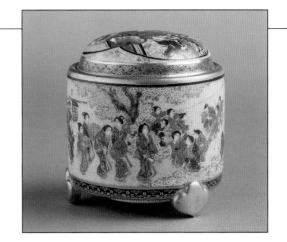

84. Earthenware koro
Signed Seikozan
1890s 7.5 cm.

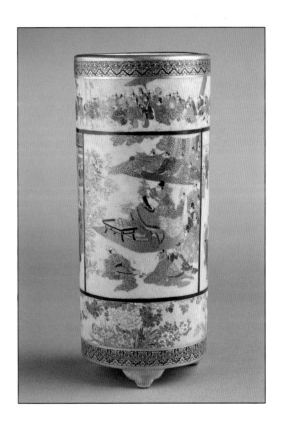

85. Earthenware brush-pot
Signed Seikozan
1890s 15.4 cm.

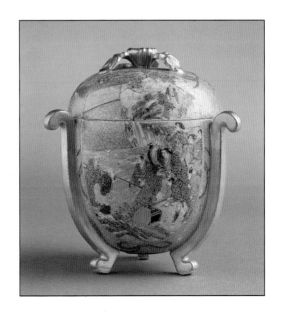

86. Earthenware koro
Signed Seikozan
1890s 10.8 cm.

Nakamura Baikei

87. Earthenware koro
Signed Nakamura Baikei Kin sei
 and bearing an inscription
 describing the complexity of
 manufacture, which took 310
 days to complete
1890s 8.5 cm.

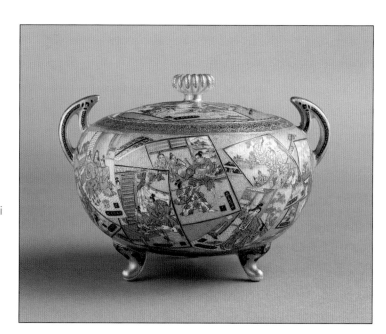

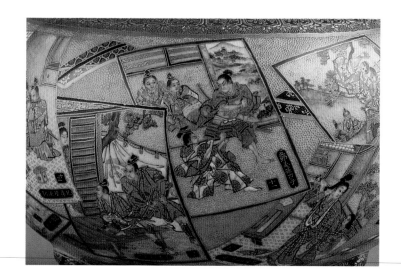

Shoko Takebe

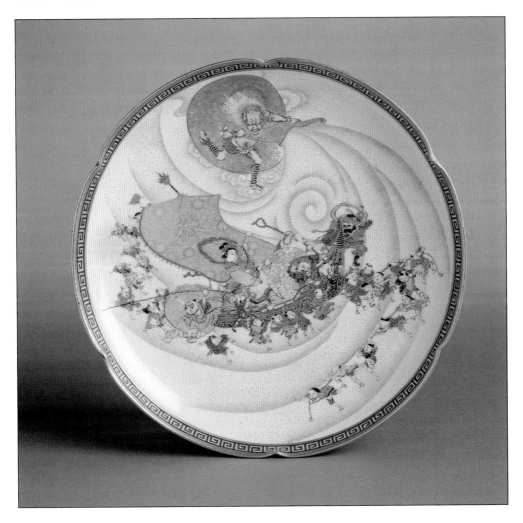

88. Earthenware plate
Signed Shoko Takebe *and inscribed in katakana* Thomas B. Blow
*c.*1900 Dia. 21.4 cm.

Thomas B. Blow was an English collector/dealer who lived in Japan in the early part of the century and commissioned pieces from Shoko Takebe. Other similarly inscribed examples are in the Baur Collection, Geneva

Ryozan

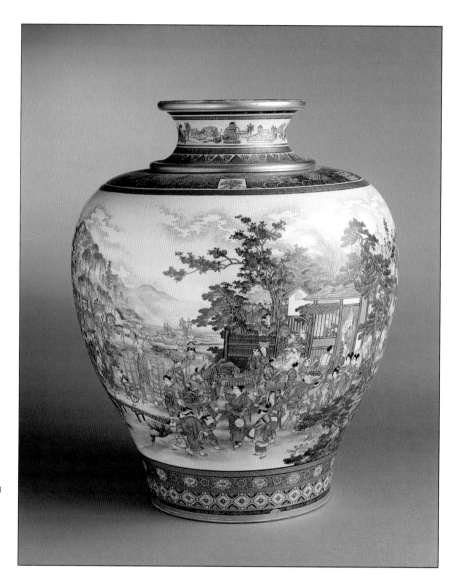

89. Earthenware vase
Signed Dai Nihon, Kyoto
 Tojiki Goshigaisha, Ryozan
 with the trademark of the
 Yasuda Company of Kyoto
*c.*1900 34.5 cm.

Hankinzan

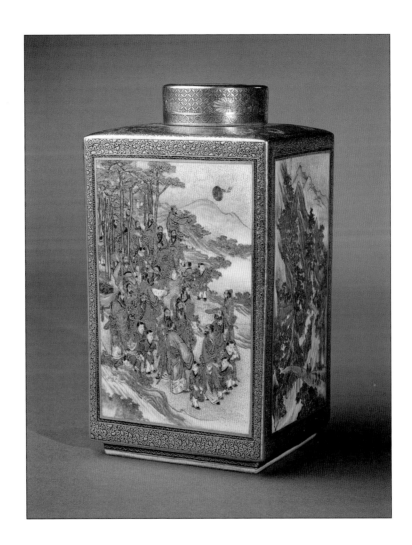

90. Earthenware tea-caddy
Signed Hankinzan do
1900–10 13.7 cm.

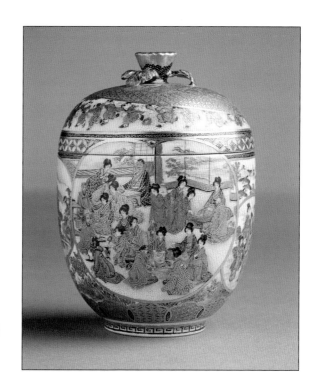

91. Earthenware lidded jar
Signed Kinzan (Hankinzan)
1900–10 10.5 cm.

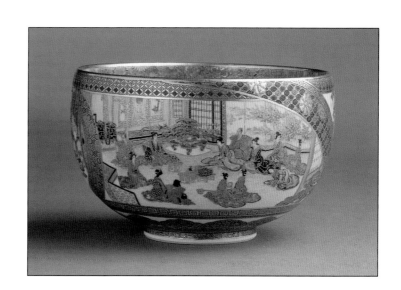

92. Earthenware bowl
Signed Hankinzan do
1900–10 Dia. 12.5 cm.

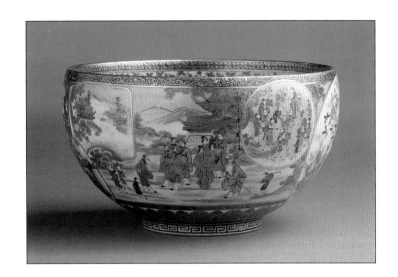

93. Earthenware bowl
Signed Hankinzan do
1900–10 Dia. 14.5 cm.

Kizan

94. Earthenware plate
Signed Dai Nihon,
Kyoto, Kizan sei *with*
seal Kizan
1900–10 Dia. 17.1 cm.

Kinkozan

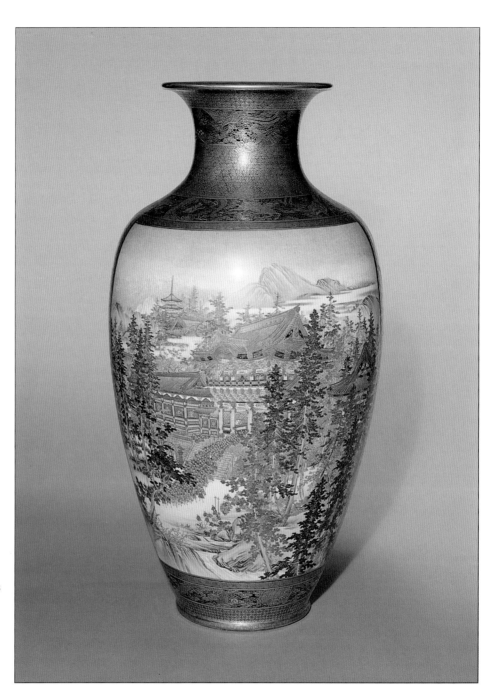

95. Earthenware vase
Signed Kyoto, Kinkozan
zo *and inscribed* James
Robinson Esq., with
Mr. G. Kobayashi's
compliments
Dated 1908 55 cm.

In a letter from Mr Kobayashi, dated 1908, he advises of the dispatch of the vase, stating: 'Having had a desire to send you something . . . I have had rather difficulty in selection . . . I have ordered a flower vase to the best maker in the district to be painted, by the eminent artist [Kozan], the scene of the Shogun's procession marching out of the Gate, Yomei-mon . . . Though it took nearly five months, considerably long time to finish only one vase it has made splendidly and the maker himself was very proud of it'

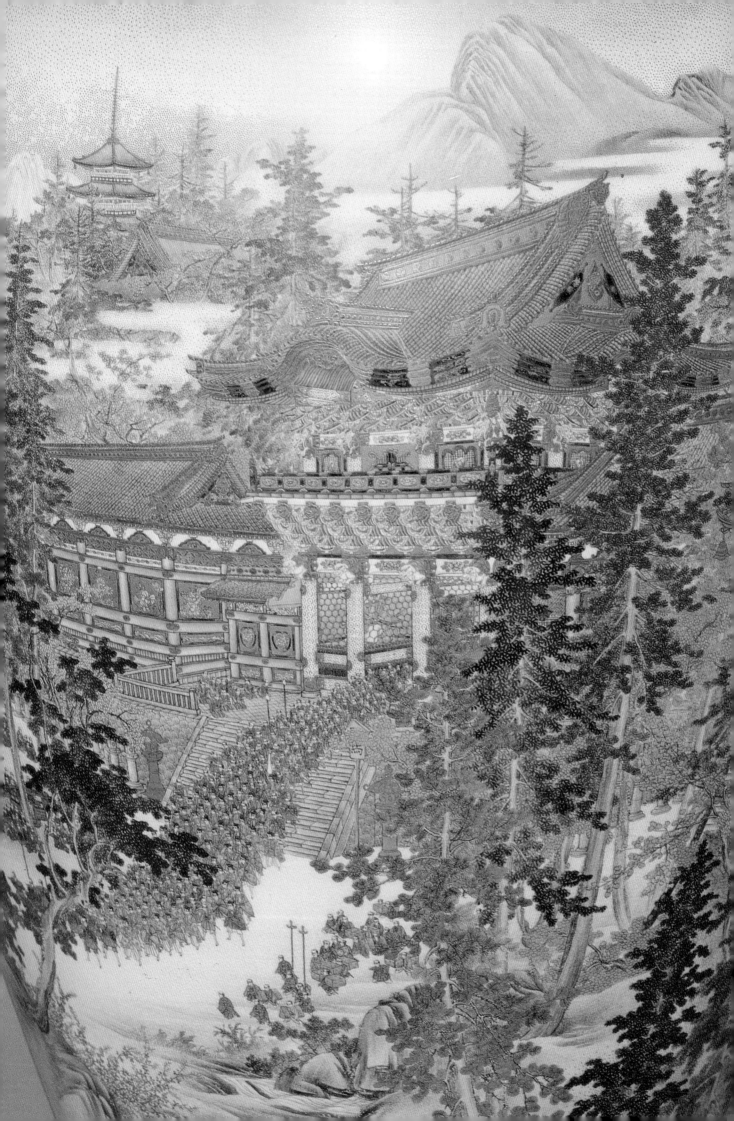

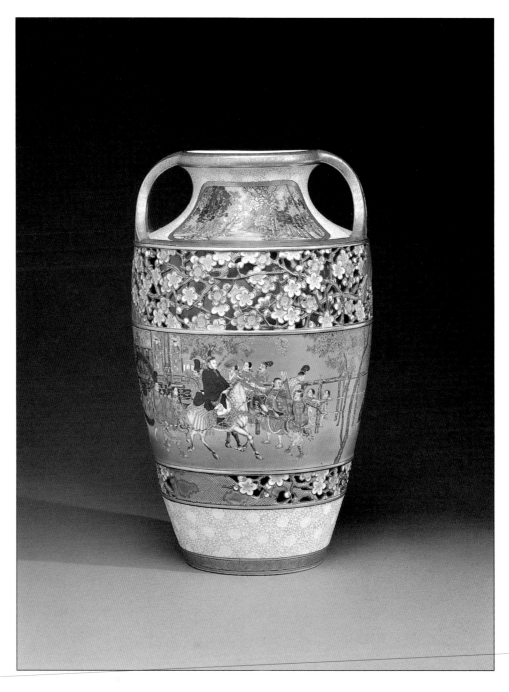

96. Earthenware vase
Signed Kinkozan *and*
painted by Chokusai
1905–10 32 cm.

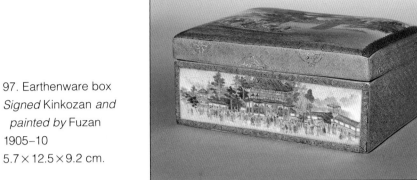

97. Earthenware box
Signed Kinkozan *and*
painted by Fuzan
1905–10
5.7 × 12.5 × 9.2 cm.

Unsigned

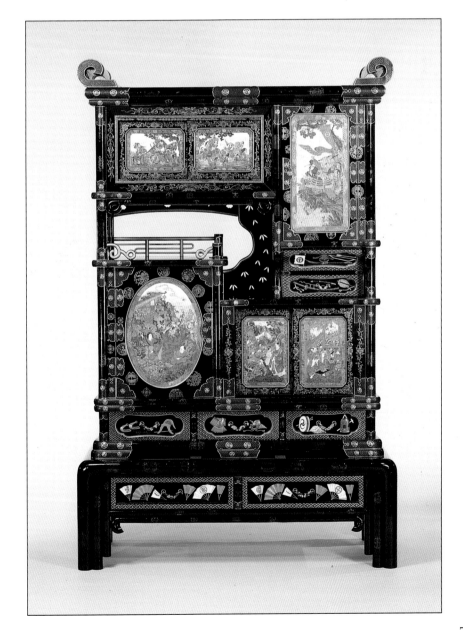

98. Porcelain-mounted
lacquer cabinet
Unsigned
*c.*1890
208 × 120 × 46 cm.

Makuzu Kozan Inoue Ryosai

 Seifu Yohei III

 Tominaga Genroku

 Kato Tomotaro

 Shofu Katei

 Seishoen

 Suwa Sozan

Yabu Meizan

Nakamura Baikei

Shoko Takebe

Ryozan

Meizan

Hankinzan

Kizan

Seikozan

Kinkozan

Glossary

celadon: porcelain covered in a blue-green iron glaze

do: made at the house of

Edo period: 1600–1868

fly-ash: wood-ash moving around in the air-currents in a kiln

go: art-name

hagi: bush clover

kaiseki: the formal meal that may accompany a tea ceremony

kakemono: a hanging scroll

Kamakura period: 1185–1336

Kangxi period (*in China*)**:** 1662–1722

koro: incense-burner

kosometsuke: 'old blue-and-white porcelain', used to describe Chinese porcelain imported into Japan in the second quarter of the seventeenth century

Kyo-yaki: enamel-decorated earthenware made in Kyoto

makimono: hand-scroll

Meiji period: 1868–1912

mukozuke: a food-dish, which may be cup-shaped

Nanga: 'Southern-style painting', the Chinese-revival style of Japanese painting in the early nineteenth century

natsume: tea-jar

noborigama: a stepped, chambered kiln

reishi: a type of fungus

Rimpa: the 'Decorative' school of painting in Japan

sei: made by

Shibayama: a style of decoration inlaid into lacquer or other backgrounds, named after the supposed originator

shogun: the hereditary *de facto* ruler of Japan until 1868

shoki-Imari: Japanese porcelain of the first half of the seventeenth century

uri: gourd

zo: made by